THE GRATEFUL DEAD
BY JIM MARSHALL
PHOTOS AND STORIES FROM THE FORMATIVE YEARS, 1966-1977

CURATED BY **AMELIA DAVIS** AND **DAVID GANS**

AFTERWORD BY **JOHN MAYER**

CHRONICLE BOOKS
SAN FRANCISCO

Dedicated to
the Best of Our Knowledge

Text copyright © 2025 by the individual writers.
Photographs copyright © 2025 by Jim Marshall.
All rights reserved. No part of this book may be reproduced in any form without written permission from the publisher.

Library of Congress Cataloging-in-Publication Data

Names: Marshall, Jim, 1936-2010, author. | Davis, Amelia, author. | Gans, David, author. | Mayer, John, other.
Title: The Grateful Dead by Jim Marshall : photos and stories from the formative years, 1966–1977 / photographs by Jim Marshall ; afterword by John Mayer ; curated by Amelia Davis and David Gans.
Description: San Francisco : Chronicle Books LLC, 2025.
Identifiers: LCCN 2024061465 | ISBN 9781797226637 (hardcover)
Subjects: LCSH: Grateful Dead (Musical group)—Pictorial works. | Rock musicians—California—San Francisco—Portraits. | Rock musicians—United States—Portraits. | Rock concerts—California—San Francisco—Pictorial works. | Rock concerts—United States—Pictorial works. | LCGFT: Photobooks.
Classification: LCC ML421.G72 M27 2025 | DDC 782.42166092/2--dc23/eng/20241226

LC record available at https://lccn.loc.gov/2024061465

Manufactured in China.

FSC MIX Paper | Supporting responsible forestry FSC™ C104723

Design by Allison Weiner.
Cover lettering and illustrations by Fez Moreno.
Typesetting by Frank Brayton.

Cover photograph: Grateful Dead, Golden Gate Park Panhandle, San Francisco, 1967.

10 9 8 7 6 5 4 3 2 1

Chronicle books and gifts are available at special quantity discounts to corporations, professional associations, literacy programs, and other organizations. For details and discount information, please contact our premiums department at corporategifts@chroniclebooks.com or at 1-800-759-0190.

Chronicle Books LLC
680 Second Street
San Francisco, California 94107
chroniclebooks.com

Phil Lesh, Bill Kreutzmann, Jerry Garcia, last concert on Haight Street, March 3, 1968.

Contents

Introduction by Amelia Davis 8

People and Places 12

Looking at You Looking at Me by Bill Shapiro 48

Origins by Dan Sullivan 98

More Jekyll than Hyde by Blair Jackson 134

Jim Marshall and the Grateful Dead by Peter Richardson 158

From the Haight to the Heights by David Gans 222

Afterword by John Mayer 280

About the Contributors 284

Acknowledgments 287

Bob Weir in a window of 710 Ashbury Street,
San Francisco, 1967.

INTRODUCTION

BY AMELIA DAVIS

The challenge: 1,352 black-and-white proof sheets, 168 boxes of Kodachrome slides, 52,704 images in all.

To create The Grateful Dead by Jim Marshall, I combed through all these 52,704 images and through a dizzying whirlwind of history. The Grateful Dead played with Jefferson Airplane, Janis Joplin and Big Brother, Quicksilver Messenger Service, the Charlatans, Santana, the Paul Butterfield Blues Band, Mike Bloomfield Band, and other San Francisco bands. Luckily for me, Jim was very meticulous when it came to organizing and cataloging his photography. He had to be because he was a working photographer, and if he didn't find a specific photograph efficiently and quickly, he would risk losing a licensing opportunity and getting paid. Jim had three-by-five cards on every subject he photographed. On that three-by-five card would be corresponding numbers that indicated every roll of film with matching proof sheets. As noted on the card for the Dead, they played at historic events such as the Trips Festival, the Human-Be-In, the Monterey Pop Festival, Haight Street & Hippies, the Northern California Folk-Rock Festival, the Newport Pop Festival, the Sky River Rock Festival, Woodstock, Fillmore West's last week, and the PERRO sessions. The Dead headlined at Bill Graham's iconic San Francisco venues—the Fillmore Auditorium, the Fillmore West, and Winterland—and other San Francisco venues like the Matrix and the Straight Theater.

My challenge included dating these images as accurately as I could. It took some close attention to what the subjects were wearing, the length of their hair, whether they were clean-shaven or not, and even what style of glasses they may have been wearing at the time or what guitars they were playing. By cross-referencing with the other bands pictured and checking what years some of the venues closed, I found that in Jim Marshall's earlier photography books, some of the dates were off. Hey, it happens to even the best of us. So if you see a date in this book that's different than a date in another Jim Marshall book, don't be alarmed! Through extensive research by David Gans, Dan Sullivan, Bonita Passarelli, and me, we have uncovered several photographic gems and have hopefully put right the historical time frame.

• • • • •

Jim Marshall always said he was a reporter with a camera, documenting what he saw around him. He was photographing history as it was happening. Jim lived and breathed photography. He had no room in his life for anyone else, and maybe that is why he had two failed marriages and no children. I think in many ways that was a blessing in disguise, because his children were his photographs, and his subjects became his family.

Jim considered the Grateful Dead part of that collective family. When he moved back to San Francisco after spending two years in New York, he rented an apartment on lower Haight Street. He immersed himself in the whole counterculture scene that was starting to form in 1965. Because Jim was an established, trusted professional photographer and everyone knew him and his photographs, the Grateful Dead welcomed him into their circles, allowing Jim unfettered access into their world. This is how Jim became part of their family and they became part of his.

Jim was a true photojournalist, and he had to be prepared for his subjects, the surroundings, and the music that was being performed; so often the Grateful Dead and the other bands of this era would throw an impromptu concert on the street or just down the block in the Panhandle. Because Jim was always present and part of the family, he would know when these impromptu events were going to take place and was ready to photograph them with his Leica cameras. With this innate ability to know that

something was going to happen, Jim was able to become one with whomever or whatever he was photographing. He never left home without his Leicas, usually five hanging from his neck and shoulders, locked and loaded, with fixed lenses set at specific focal lengths and filled with Tri-X 400 and Kodachrome, ready to shoot.

The Grateful Dead was very much an improvisational band, and this made Jim the perfect person to photograph them. They played off what was happening at that moment, so no song was ever the same. Jim's photographs of the Grateful Dead are never the same either. When you look at this collection of photographs, you feel the music, hear the music, smell the music, and become part of the band!

Part of Jim's genius as a photographer was his ability to capture pure chaos—the chaos of the Dead playing live onstage, going right up to the speakers and getting feedback from them while the others onstage were holding their ears. But he could also capture quiet and loneliness, as in the photo of Pigpen walking down the street by himself. Two very different images, yet in both, you can feel and see the emotions through Jim's lens. That's who Jim was:

a complex man who could be a calm photojournalist or a manic mess or a lonely soul looking for someone or something to fill the void.

Jim went through life collecting his photographic children and keeping them close to him. He fiercely protected them and would not let his children be hurt, exploited, and/or stolen from him. Jim even decided which ones he would allow the world to see and which were too personal (those he kept in drawers, to be shown only when he wanted them to be shown, revealing a part of himself that he wanted to be revealed). In going through these drawers and proof sheets, I discovered some hidden gems and decided it was time to let the world see these images for the first time. His children could elicit joy, hope, excitement, pain, fear, and sometimes sorrow. But no matter what, they were part of Jim's family. Jim was there with the Dead through the ups and downs, the on-again, off-again friendships; the break-ups, makeups, girlfriends, wives, daughters, and sons; the drug busts, losses, and changes; the quiet moments and the explosive moments. The challenges of family. The Grateful Dead was family.

Pigpen, 1967.

Grateful Dead, Newport Pop Festival, Orange County Fairgrounds, Costa Mesa. August 4, 1968.

PEOPLE AND PLACES

People

The Grateful Dead Family

Jerry Garcia
Lead guitar and vocals

Ron "Pigpen" McKernan
Keyboards, harmonica, percussion, and vocals

Bob Weir
Guitar and vocals

Phil Lesh
Bass guitar and vocals

Bill Kreutzmann
Drums

Mickey Hart
Drums

Donna Jean Godchaux
Vocals from 1972 to 1979

Keith Godchaux
Keyboards from 1971 to 1979

Carolyn "Mountain Girl" Adams Garcia
Merry Prankster, later Jerry Garcia's wife

Ken Kesey
Author, Merry Prankster

Sunshine Kesey
Mountain Girl's daughter

Susila Ziegler
Bill Kreutzmann's wife

Rosie McGee
Dancer, Phil Lesh's girlfriend

Danny Rifkin
Comanager from 1966 to 1985

Rock Scully
Comanager from 1966 to 1985

Veronica "Vee" Grant
Pigpen's girlfriend

Lawrence "Ram Rod" Shurtliff
Equipment manager

Sam Cutler
Tour manager from 1970 to 1974

Allan "Gut" Terk
Hells Angel, Merry Prankster, album cover and poster artist

Betty Cantor-Jackson
Sound engineer and record producer

Bob Matthews
Sound engineer and record producer

Jerry Garcia, Mountain Girl, and their dog, Lady, 710 Ashbury, 1967.

The Others

Jorma Kaukonen
Guitar, Jefferson Airplane

Jack Casady
Bass guitar, Jefferson Airplane

Grace Slick
Vocals, Jefferson Airplane

Marty Balin
Vocals, Jefferson Airplane

Bill Thompson
Manager, Jefferson Airplane

Janis Joplin
Vocals, Big Brother & the Holding Company

Bill Graham
Concert promoter synonymous with the Fillmore Auditorium, the Fillmore West, and Winterland

Chet Helms
Concert promoter at the Fillmore Auditorium and the Avalon Ballroom

"Freewheelin' Frank" Reynolds
Secretary, San Francisco chapter of the Hells Angels

Michael Bloomfield
Guitar, the Paul Butterfield Blues Band

David Crosby
Guitar and vocals, Crosby, Stills, Nash & Young

Neil Young
Guitar and vocals, Crosby, Stills, Nash & Young

Al Kooper
Songwriter, producer, studio musician

Jimi Hendrix
Guitar and vocals, the Jimi Hendrix Experience

Buddy Miles
Drums and vocals, the Electric Flag

Michael Shrieve
Drums, Santana

Steve Winwood
Keyboards, vocals, and guitar, Traffic

Jim Capaldi
Drums and percussion, Traffic

Chris Wood
Flute and saxophone, Traffic

Eric Clapton
Guitar and vocals, Cream

John Cipollina
Guitar, Quicksilver Messenger Service

Gary Duncan
Guitar and vocals, Quicksilver Messenger Service

Dan Hicks
Drums and vocals, the Charlatans

Steve Miller
Guitar and vocals, Steve Miller Band

Michael Stepanian
Lawyer, cofounder of the Haight Ashbury Legal Organization (HALO)

Steve Schapiro
Photographer

Baron Wolman
Photographer

Dusty Street
Disc jockey, KMPX-FM

Bert Kanegson
Peace activist, concert organizer, yogi

Renée LeBallister
Dancer

Julius Karpen
Manager, Big Brother & the Holding Company

Ron Polte
Manager, Quicksilver Messenger Service

Herbie Greene
photographer

Places

710 Ashbury Street
Communal home of the Grateful Dead from September 1966 to March 1968. Three blocks south of the Panhandle, five blocks east of Golden Gate Park, and one block up the hill from Haight Street.

Longshoremen's Hall
400 North Point Street
Union hiring hall located near Fisherman's Wharf. Site of several of the first San Francisco rock dance concerts, starting in fall 1965. Site of the Trips Festival, across three memorable days in January 1966.

Fillmore Auditorium
1805 Geary Boulevard
Historic venue at the corner of Geary Boulevard and Fillmore Street. Opened in 1912 as the Majestic Hall and renamed the Fillmore Auditorium in 1954. Bill Graham began producing concerts there in December 1965. Known for spectacular light shows, appreciative audiences, and Graham's eclectic booking policy, it was a locus of the San Francisco counterculture scene and inspired similar venues across the country. Graham moved operations to the Fillmore West in July 1968. The renovated venue reopened in 1994 and is currently operated by Live Nation.

Grateful Dead, Lindley Meadow, Golden Gate Park. September 28, 1975.

Fillmore West
10 South Van Ness Avenue
Not to be confused with the Fillmore Auditorium, the Fillmore West was located about a mile and a half away in the Civic Center neighborhood. Opened in the 1920s as the El Patio Ballroom. In March 1968 the Grateful Dead, Big Brother & the Holding Company, Quicksilver Messenger Service, and Jefferson Airplane formed a collective and began holding concerts in the space, which they called the Carousel Ballroom. That same month Bill Graham opened an outpost in New York City, which he named the Fillmore East. The Carousel Ballroom collective soon ran into financial problems, and in July 1968 Graham took over the Carousel lease, moved his operation across town, and rechristened the space the Fillmore West. It closed on July 4, 1971, after five nights of shows featuring the top local bands, including the Grateful Dead.

The Panhandle
Stanyan Street and Fell Street
Narrow city park located two blocks north of Haight Street, extending eight blocks east from Golden Gate Park. Site of many free concerts and happenings during the neighborhood's 1965–68 heyday.

Golden Gate Park
Largest city park in San Francisco, home to cultural institutions including the de Young Museum, California Academy of Sciences, Japanese Tea Garden, and National AIDS Memorial Grove. Haight Street terminates at the eastern end of the park, which stretches three miles west to the Pacific at Ocean Beach. Like the Panhandle, Golden Gate Park became a countercultural institution during the late 1960s, hosting numerous free concerts and community happenings.

The Polo Fields
Golden Gate Park
Huge open sports field surrounded by a cycling track, near the center of Golden Gate Park. Site of the Human Be-In, which drew tens of thousands to a celebration of the nascent counterculture on January 14, 1967, and numerous free concerts. Since 2008, home of the annual (and decidedly not free) Outside Lands music festival.

Speedway Meadow
Golden Gate Park
Narrow tree-lined meadow just east of the Polo Fields. Renamed Hellman Hollow in 2011, in honor of billionaire philanthropist and banjo player Warren Hellman, founder and funder of the free Hardly Strictly Bluegrass festival, held in the park each fall since 2001.

Lindley Meadow
Golden Gate Park
Another long, narrow lawn, perfect for free concerts. Just north of the Polo Fields.

Family Dog on the Great Highway
Balboa Street and Great Highway
From 1966 to 1968, the Family Dog commune produced concerts at another classic San Francisco venue, the Avalon Ballroom in the Lower Nob Hill neighborhood. In 1969 the group took over a rickety building five miles away, directly across the Great Highway from Ocean Beach. Built in 1883, the space had been a casino and ballroom into the 1920s, then a restaurant called Topsy's Roost, which was popular with patrons of the nearby Playland at the Beach amusement park. The Family Dog held concerts there between June 1969 and June 1970. The building was demolished, along with Playland, in late 1972.

Wally Heider Studios
245 Hyde Street
Opened in March 1969, the first truly world-class recording facility in San Francisco. Site of numerous sessions by the Planet Earth Rock and Roll Orchestra (PERRO); members of the Grateful Dead; Quicksilver Messenger Service; Jefferson Airplane; and Crosby, Stills, Nash & Young, who regularly played on one another's albums between 1970 and 1972. Still operating today as Hyde Street Studios.

Winterland
2000 Post Street

Former ice rink, opened in 1928, located about three blocks from the Fillmore Auditorium. Bill Graham began renting it occasionally in September 1966 for concerts that were expected to draw more than the Fillmore Auditorium could hold. After closing the Fillmore West in 1971, Graham took over Winterland and ran it as a concert-only venue. Its final show was an all-nighter on New Year's Eve 1978, featuring the Blues Brothers, New Riders of the Purple Sage, and three sets from the Grateful Dead, followed by hot breakfast for all in the morning.

The Matrix
3138 Fillmore Street

Opened by Jefferson Airplane's Marty Balin and three partners in August 1965, and initially managed by Balin himself, this one-hundred-seat nightclub featured the Airplane as its original house band. It was a favorite of San Francisco bands as well as touring rock, jazz, and blues artists. From late 1968 it became famous for "Matrix jams," with local and out-of-town musicians coming by on their nights off to play together. It closed in 1972.

Straight Theater
1700 Haight Street

Opened as the Haight Theater in 1910, hosting vaudeville as well as cinema. In 1964 new owners briefly transformed it into an experimental gay theater, prompting neighborhood outrage. It then sat empty until a group of young artists took over. The renamed Straight Theater opened in August 1967. Responding to further community backlash, the police department denied the dance permits necessary to host rock concerts. However, no permits were needed to run a dance school, so the owners hired the Grateful Dead to play a series of what were billed as "dance classes." Eventually the city issued permits, and the owners continued to hold events for about two years before closing for good in 1969. The building was demolished in 1981.

Le Club Front
20 Front Street, San Rafael

A warehouse in the Canal District of suburban San Rafael, about fifteen miles north of the Golden Gate Bridge in Marin County. It was converted in 1977 into a rehearsal space for the Jerry Garcia Band. In 1978 it was transferred to the Grateful Dead and became the band's longtime recording studio, warehouse, rehearsal space, and hangout.

Marin Headlands
The hilly peninsula at the very southern tip of Marin County, just across the Golden Gate Bridge from San Francisco. Famous for its stunning views of the bridge and city.

Opposite: Straight Theater "Dance Class" marquee. September 29, 1967.

This page, top: Grateful Dead, KQED-TV *A Night at the Family Dog* special, Family Dog on the Great Highway. February 4, 1970.

This page, bottom: Bob Weir, backstage at Winterland, 1971.

Grateful Dead proof sheet, 1967.

Jim Marshall was right out of a Damon Runyon story. He was a unique character. He had such energy, and he was a joy to be around. He took joy in putting people on edge, and he would test you. If you failed the test, he didn't hang with you. I feel very fortunate and privileged to have been his friend because I consider him one of the great talents of the twentieth century behind the camera.

—Bob Sarles
filmmaker and friend

Grateful Dead, the Panhandle, 1967.

Rock Scully, 710 Ashbury, 1968.

Veronica was Pigpen's girlfriend. She was just a lovely person, and she lived with us sometimes. They were a very tight couple for years, and she was a nurse and went to work pretty much four or five days a week. We loved her. She was funny, too, and enjoyed living communally.

This photo shows Vee before she got her hair cut. She had to cut her hair to go to nursing school. Not what she wanted, I don't think. She went to nursing school for several years and got her degree. Did the whole thing while we were all living together at 710 Ashbury. She was determined to get that degree. Vee was a wonderful person.

—Mountain Girl

Pigpen and Vee, 1968.

Grace Slick, Jerry Garcia, Steve Miller, John Cipollina, and Dan Hicks, in the Marin Headlands. February 26, 1976. Shot for "San Francisco Ten Years On" in *Rolling Stone* magazine, no. 207.

Pigpen, Newport Pop Festival, Orange County Fairgrounds, Costa Mesa. August 4, 1968.

Jim came into San Francisco with credentials. Those jazz shots gave him an authority, and of course he had an indomitable drive to get the picture. He had that New York energy, and it was still early enough that no one was gonna tell him he couldn't lie on the stage. There were crew members in those days that could have, but I think they admired him just because he was so ballsy. And this was gonna make a great shot.

—Dennis McNally
Grateful Dead publicist and biographer

Grateful Dead, final week of concerts at the Fillmore West.
July 2, 1971.

Jerry Garcia, David Crosby, Phil Lesh, and Neil Young, PERRO
(the Planet Earth Rock and Roll Orchestra) recording sessions,
Wally Heider Studios, 1971.

Phil Lesh, Donna Jean Godchaux, and Bob Weir, Lindley Meadow, Golden Gate Park. September 28, 1975.

Mountain Girl, 1967.

Bill Graham, Pigpen, and Danny Rifkin in the Panhandle, 1966.

Jerry Garcia and Chet Helms, Artists Liberation Front Free Fair in the Panhandle. October 16, 1966.

Mickey Hart, Lindley Meadow, Golden Gate Park.
September 28, 1975.

Grateful Dead, KQED-TV *A Night at the Family Dog* special, Family Dog on the Great Highway. February 4, 1970.

Grateful Dead, across Geary Street from the Fillmore Auditorium, 1966.

Phil Lesh and Rosie McGee, the Panhandle, 1966.

Pigpen, Artists Liberation Front Free Fair in the
Panhandle. October 16, 1966.

I was still in high school, but I had a friend named Peter Corbetta, who was from a very prominent family in Los Altos. He bankrolled some of the first concerts at the Continental Ballroom and later the San Jose folk-rock festival.

I first met Jim maybe in '67 or '68. He approached me at one of the outdoor shows—either the Panhandle or Hippie Hill. He had seen me at a poetry reading at City Lights Bookstore previous to that and asked me if I had been at this reading.

We kind of struck up a conversation about poetry, of all things. He actually was kind of a closet literate!

—Pattie Spaziani O'Neal
high school classmate of Bob Weir

Pigpen and Jerry Garcia, Northern California Folk-Rock Festival, Santa Clara County Fairgrounds, San Jose. May 18, 1968.

Jim was a friend, and I loved him very much. I loved him because of who he was *and* in spite of who he was. He was not an easy guy to be friends with. You had to be persistent.

—Bob Sarles

Al Kooper, Mountain Girl, Jerry Garcia, and Jack Casady, backstage at the Matrix. January 20, 1969.

Vee and Pigpen, Northern California Folk-Rock Festival, Santa Clara County Fairgrounds, San Jose. May 18, 1968.

Opposite, top: Light show backdrop, Fillmore Auditorium. October 9, 1966.

Opposite, bottom: Pigpen, 1968.

This page: Grateful Dead, New Year's Eve, Winterland. December 31, 1968.

Jim was such an interesting cat on so many levels. He wasn't a portrait photographer. All his stuff was candid. He did album covers for me and a lot of people, but that really wasn't his thing. Jim's thing was capturing stuff that nobody else probably could have gotten, because he was so pushy. Jim was always pushing the envelope in some way.

—Jorma Kaukonen

Phil Lesh and Rosie McGee, Speedway Meadow, Golden Gate Park. July 4, 1967.

The Airplane—strange, idiosyncratic beast that it was—drove Jim crazy when he had to take pictures. As soon as we sensed weakness or some kind of discomfort, the soft underbelly would be revealed and everybody in the band would jump on it immediately. That said, Jim gave as good as he got at any given moment, and in that moment, he was part of the gang.

—Jorma Kaukonen

Jorma Kaukonen, Jerry Garcia, Jack Casady, and Pigpen, Speedway Meadow, Golden Gate Park. July 4, 1967.

Jerry Garcia in the Panhandle, 1966.

Grace Slick, Jerry Garcia, Steve Miller, John Cipollina, and Dan Hicks in the Marin Headlands. February 26, 1976. Shot for "San Francisco Ten Years On" in *Rolling Stone* magazine, no. 207.

There are photographers who are very visual—Ansel Adams and Edward Weston. And then there are photographers who are more about people, about human situations: photojournalists. Jim Marshall definitely falls into the second category, as a guy who's trying to capture something going on between people or about people.

—Dave Getz
drummer for Big Brother & the Holding Company

Jimi Hendrix and Buddy Miles, at the Jimi Hendrix Experience free concert in the Panhandle, the weekend after Monterey Pop Festival. June 25, 1967.

LOOKING AT YOU LOOKING AT ME

LOOKING AT YOU AT ME

BY BILL SHAPIRO

Late on the night of January 23, 1966, in a hulking, hexagonal spaceship of a building where, by day, San Francisco's longshoremen gathered, something extraordinary happened. It was the second night of the Trips Festival, and the Acid Tests, until then hush-hush, invite-only underground affairs, suddenly dropped the tie-dyed veil of secrecy and welcomed anyone willing to burn two bucks on a ticket. The band until recently known as the Warlocks—their brand-new "Grateful Dead" name fewer than a dozen shows old—performed, as did Big Brother & the Holding Company. Owsley was there, Kesey was there, and so were Bill Graham, Mountain Girl, Stewart Brand, and various Pranksters. The journalist Tom Wolfe would later declare of the Trips Festival, "The Haight-Ashbury era began that weekend."[1]

But the night stands out for another reason: It was the first time Jim Marshall photographed the Dead. Jim would go on to become one of the most celebrated, most prolific music photographers of all time, famously shooting Jimi setting his guitar on fire at Monterey, Janis clutching a fifth of Southern Comfort backstage at Winterland, and Johnny Cash flipping the bird at San Quentin. Jim shot Dylan and Daltrey, the Stones and Santana, Miles and Trane—everyone from the Airplane to Zeppelin. He shot his generation's biggest musical moments: the Monterey International Pop Festival, Woodstock, Altamont. As for the Dead, Jim photographed them onstage and backstage, in the park and on the street, inside diners and vans and 710 Ashbury, in black and white and in beautifully saturated Kodachrome color. Over the years he took exactly 6,624 pictures of the Dead—among them, some of the most iconic photos of the band ever made.

And yet many of Jim Marshall's Dead pictures have, until now, never been seen. They remained squirreled away in his massive archive for decades. Looking at this tremendous body of work, both the seminal and the unseen, what emerges is the story of a man who was more than a music photographer or a fine-art photographer or a portraitist or even a photojournalist. He was, really, an artist of such vision, talent, and timing—and so obsessive in his practice—that he was able to capture the fast-flowing zeitgeist as it unrolled, in real time, before his lens.

You can see this in those early images made at the Trips Festival: Jim's focus wasn't on the band, because the festival wasn't about the music; he was capturing the 360-degree *experience*, the acid-drenched circus of lights and sound and wild projections; of dancers, screamers, spinners, trampoliners; of strobing, looping, whooping, and even thunder machines. (As Garcia has been quoted as saying, "It was a great, incredible scene. . . . I had some sense that the Grateful Dead was supposed to play sometime maybe. But it really didn't matter.")[2]

What Jim zeroed in on over the course of that incredible night reveals how he looked for pictures. He certainly could have photographed hippie couple after hippie couple in full-on freak regalia, but instead, like Tom Wolfe, Jim understood the meaning of the moment. To my eye, his most stunning shot from that night (page 51) focuses on a relatively straight couple—the woman has no flowers in her hair, and the guy is, without irony, wearing a tie—because this was the night when everything changed, when the doors flung open, when even the straights nipped at the Kool-Aid.

1 Tom Wolfe. *The Electric Kool-Aid Acid Test* (Farrar, Straus and Giroux, 1968).

2 Michael Kramer. "Inside Outside: On the Significance of the Trips Festival," California Historical Society, article published January 27, 2016. https://experiments.californiahistoricalsociety.org/inside-outside-on-the-significance-of-the-trips-festival/.

"The fact that Jim was even there is incredible," says Jodi Peckman, a thirty-one-year veteran of *Rolling Stone* and the magazine's director of photography from 1994 to 2018. "It wouldn't be something that most photographers would flock to, because the Grateful Dead weren't famous then," she told me. "But Jim knew it was important because he was *right there*, in San Francisco, living it. It's amazing that these pictures even exist."[3]

Time and again, Jim found the moment that mattered. Just look at his March 3, 1968, picture of the Dead's last show on Haight Street (pages 4–5), an image that has entered the collective memory of every longtime Head and has become *the* defining image of the concert. It's a frame filled with both palpable intensity (Billy's face!) and unlimited devotion (the crowd goes on *forever*). But for me, what makes this picture sing is its astonishing composition: Phil's bass points us directly to an open-mouthed blond woman in the front row whose eyes are locked on Billy, and his eyes are locked on Jerry. And Billy's cymbal? Smack in the middle of the frame, leading us to that vanishing point off in the deep distance. Peckman loves the perspective, "how the crowd goes creeping down the street into a little V."[4]

• • • • •

Beginning that January night in 1966 at the Longshoremen's Hall, more than a year before the Dead released their first album, and lasting until about the time *Terrapin Station* hit record-store bins in 1977, Jim shot the Dead with astonishing frequency. When the Dead played—in the park or the Panhandle, at Winterland or the Fillmore or the Family Dog—Jim was there. And when the Dead weren't playing, well, he was there too, often hanging out at the band's four-story, 2,600-square-foot Haight-Ashbury rental.

In the early days, Jim and Pigpen bonded over a shared passion for the blues and loud motorcycles . . . and maybe also because they were the only two acid-avoidant guys in the scene. But soon enough, Jerry befriended Jim—and quickly came to understand how much Jim's images could help his up-and-coming quintet. It was a matter of two inspired artists "getting" each other, of game recognizing game.

3 Jodi Peckman, in discussion with the author, spring and summer 2023.
4 Ibid.

So how did Jim Marshall get game?

In 1962, after a few years in San Francisco shooting mainly jazz and blues musicians, Jim moved to New York City. He was just twenty-six. While he continued photographing performers in dive bars, in swanky clubs, and for record labels, it was here that he trained himself to be an exceptional street photographer. Amid the hustle and jostle of the city's bumper-car sidewalks, he learned to react to a quick-moving moment in a fraction of a second.

And he learned something else, something that would have an incalculable impact on his career: He learned how to disappear. Jim became adept at lifting the camera to his eye and somehow photographing a fleeting, vulnerable scene without being spotted by his subjects. Among my favorites from this period is a photo of a young couple kissing next to one of those coin-operated scales with lettering that slyly reads "Weigh your fate." Jim was there and not there at the same time. This skill primed him to be able to float backstage or in the Dead's private spaces, capturing incredible, intimate moments without disturbing the flow, without drawing attention to himself. In some ways, Jim's street photography skills were his secret sauce.

• • • • •

It also helped that Jim had always been an obsessive gear guy whose camera-handling skills were not unlike those of a Navy SEAL who can assemble an automatic weapon while blindfolded—which, given Jim's own over-the-top firearm infatuation, he probably could have done as well. If you've ever seen a picture of Jim, it's likely that he had at least a couple of cameras—Leicas, always Leicas—draped over his shoulders; at Woodstock, no fewer than five cameras hung from his neck. (It's said that the manic photographer in *Apocalypse Now*, adorned with half a dozen cameras and played by Dennis Hopper, was based on Jim.) His cameras had fixed lenses, and he knew exactly which one he needed for any situation that arose—crowd shot, close-up, low light, color, black and white, etc. He would switch nimbly, intuitively among them. The camera was such an extension of his hands that he never needed to take his eyes off the action to adjust his settings or reload his Tri-X 400 film. This meant never having to say, "That was a great look, Mickey. But I need to get my flash, so, um, could you just, like, do it again?" He wasn't intrusive, and the Dead loved that about him. Being a "fly on the wall" is

Top: Proto-Deadheads, Trips Festival, Longshoremen's Hall. January 23, 1966.

Bottom: Bird's-eye view, with a fish-eye lens and a filter, of Carlos Santana on stage at the Woodstock Festival, Bethel, New York, 1969.

about the most overused cliché in documentary photography, but the phrase could have been invented for Jim.

"Jim kind of made himself invisible," says Mark Seliger, the celebrated portraitist who has probably shot more single-name stars than any photographer ever (including Bowie, Kobe, Bono, Bruce, Snoop, Serena, Mick, Keith, Gaga, and Obama, not to mention one Jerome John Garcia ambling through an Indiana wheat field) as well as a staggering 188 covers for *Rolling Stone*. He was also pals with Jim. "Jim would be right there, near his subjects," Seliger told me. "But they never felt it. It's almost impossible to do that."[5]

Jim's ability to see the moment without stopping it, without changing it, without becoming a part of it, is the difference between someone who takes pictures and someone who captures moments. "You never feel his presence in the photo," Seliger says. "You feel like this moment would be happening whether or not Jim was in the room."[6] When you look at a close-up like the one Jim made of a pigtailed Jerry locked in conversation with Pigpen at the Newport Pop Festival in 1968 (page 122), you instantly understand what Seliger is talking about: It's a private moment that, thanks to Jim, we're allowed to see.

The Dead were clearly drawn to Jim's innate sense of timing and his ability to pick up on barely perceptible signals—subtle shifts in body language, sounds, or changes in, like, the *vibrational energy*. When playing at their best, the band tuned into the very same signals. All of which led them to trust Jim to record real moments, moments that mattered . . . but also, you know, to be *discreet*. Which he was. Case in point: When *Life* magazine sent Jim to cover the Rolling Stones' famously coke-fueled, hard-R-rated 1972 tour, he returned with now-classic images, of which precisely zero depict the debauchery that occurred.

• • • • •

There are those photographers who find their spot and then, like a well-trained marksman, patiently wait for a beautiful shot to materialize. Jim was not one of them. Whether you chalk it up to his ambition to make the single picture that crystalized the essence of an event, to his competitive spirit, or to the cocaine he loved so much, Jim would pinball around concert venues. He hunted relentlessly for the perfect angle and most compelling composition. Herbie Greene, who made many memorable portraits of the Dead, was so sweet-natured that at concerts, as he once told David Gans, he tried to avoid blocking fans' sight lines, even for a minute. Jim, on the other hand, had sharp elbows, and he didn't mind hampering someone's view if it meant getting *the photograph*, the one that people would stare at, the one that would be remembered for decades—and, of course, the one he'd be paid for. As the legendary photographer Robert Capa once famously said, "If your pictures aren't good enough, you aren't close enough."[7] Jim got close. Sure, he'd block your view during an epic "The Other One," but his photo? *That* was forever. And he knew it.

Studying the contact sheets from Jim's concert shoots offers a clear sense of his always-in-motion style. At Woodstock, for instance, he was in the crowd, in the mud, on the stage, backstage, and perched waaaaay the hell above the stage atop scaffolding. (It was from this vantage point that he took the fish-eye photo of the crowd that became the glorious gatefold of the Woodstock album.) But that wasn't enough for Jim: It was on his open-eyed wanderings *behind* the Woodstock stage that he came upon a still-thin, not-yet-graying, thoroughly amused Garcia sitting cross-legged and alone in the dirt, a crumpled can in his hand. And, providentially, a sign reading "Dead End" lying just behind him. Jim knew a moment when he saw one, and this frame has become one of the most iconic images of Jerry ever made (page 71).

• • • • •

From the very beginning, Jim had always demanded total, unfettered access to the musicians he shot, and from the beginning, it had always been granted to him. And not just with the Dead: Jim was one of very few all-access photographers at Woodstock and was the o*nly* photographer backstage for the Beatles' final paid show, at Candlestick Park in 1966. But as the music industry matured and embraced middle management, and as the Dead went from

5 Mark Seliger, in discussion with the author, spring and summer 2023.

6 Ibid.

Couple kissing in front of Village Pain Shop in Greenwich Village, New York City, 1963.

7 Magnum Photos, https://www.magnumphotos.com/shop/events/exhibitions/robert-capa-photographs-beyond-the-war/.

being a band of wildly talented misfit acidheads to a sort of grown-up-ish operation, Jim found himself negotiating with managers, handlers, and press people. When they began to throttle his access, Jim got fed up, and in an "OK, then fuck it" kind of way, he took his Leicas and went home. (It's worth noting that this was also about the time he got heavily into coke, which may have had an impact on his decision-making.)

The last time Jim photographed Jerry was in 1977 at Le Club Front, the Jerry Garcia Band's rehearsal space in San Rafael. He shot Jerry, in both black and white and color, against lush velvet curtains, gamely holding Wolf, his legendary guitar (page 96). While there, Jim also took twenty-plus frames of Keith, Donna, and bassist John Kahn against those same curtains. But the most memorable picture came earlier in the day, when a grinning Garcia raised an oversize glass goblet to Jim's camera, seemingly offering us a sip of whatever he's having. That portrait became a classic among Heads of a certain era, as it later appeared on the cover of the popular bootleg album *Farewell to Winterland*.

Jim shot just three rolls of film that day, and when he made his final photo of Jerry—frame number thirteen on the last roll—it was the end of an era.

• • • • •

As a man—one who was both wildly talented and compulsively self-destructive—Jim's legacy sits somewhere between complicated and messy. But as a photographer, it's elegantly straightforward: His pictures brought us closer to Jerry, Bobby, Phil, Mickey, Billy, and Pigpen than we had any right to be, showing us a side of them we couldn't otherwise have glimpsed even if we'd been riding the rail at the Fillmore. Mark Seliger told me that he considers Jim to be in the same league as one of the greatest ever to hold a camera, calling him the "Henri Cartier-Bresson of rock and roll."[8] Theron Kabrich, who owns the renowned San Francisco Art Exchange gallery, says, "Jim was like a butterfly catcher, and if you look at his archive, you'll see it's filled with exotic butterflies. He could tell the whole story in a single frame."[9] And Jodi Peckman puts it like this: "Jim Marshall was a huge presence, as important as the people in his photos. He lived the life, and the musicians thought of him as one of their own. He was doing what they were doing. He was making art too. He was just doing it with a camera."[10]

Thumbing through the images in this book—from that last show on Haight Street, to the postbust news conference at 710 Ashbury (page 161), to the performance shots that appeared inside *Live/Dead* (pages 58–64)—it's easy to think that Jim simply had an uncanny ability for taking pictures of the Dead's most iconic moments. But the truth is, it's Jim Marshall's photos that *made* the moments iconic. After all, at the time Jim took these photographs, especially the early frames, no one on earth could have guessed that this ragtag band would one day sell out the country's largest football stadiums, that legions of fans would commandeer school buses and cram into VW vans to travel 650 miles to the next show, or that the band would eventually release more than 276 albums. Or, perhaps most unbelievable of all, that Weir, sporting a black suit jacket and sandals, would sing "Shakedown Street" at the Kennedy Center—backed by a 96-piece orchestra, for god's sake. "Having a camera is great," Kabrich told me. "And having access is great. But anticipating what that shot will come to represent decades later? That's not by accident. That's something special."[11]

Jim Marshall's archive holds over a million photos. If you pull open one particular file cabinet, flip through the dozens of folders that hold his Grateful Dead images, and keep flipping all the way to the very last folder, you'll come to the contact sheets from his final shoot with Garcia, the one from Le Club Front in '77. You'll notice that Jim made 108 frames that day, and that he marked his favorites with yellow and red grease pencil. And, if you look carefully enough, you might spot something else: Toward the upper left corner, just to the right of frame number six, a faint fingerprint was frozen onto the contact sheet as it was pulled, still damp, from the developing tray. That fingerprint belongs to the photographer, of course.

Once again, Jim Marshall left his mark.

8 Seliger, in discussion with the author.

9 Theron Kabrich, in discussion with the author, spring and summer 2023.

10 Peckman, in discussion with the author.

11 Kabrich, in discussion with the author.

Jerry Garcia and Wolf, Le Club Front, 1977. Jim's thumbprint can be seen on the second row, between the first and second pictures.

Grateful Dead, last concert on Haight Street. March 3, 1968.

Grateful Dead, rooftop view from 1701 Haight Street of last concert on Haight Street. March 3, 1968.

When we saw that picture of the Haight Street concert, it was just a complete surprise to everybody—to look at that picture and try to calculate how many people are in it and how many people were actually there. We really didn't see it like that; I was down on the ground.

Someone would say, "This is a great day. Let's go play in the street." And somebody, likely Rock Scully, would've already hired a flatbed truck for the bands to set up on. That setup moves quickly, and you can take the truck out of there in a hurry if you need to. This was about the biggest of any of those events. I think it was one of those moments when the bands realized that they were going to enter the stream of popular music. They were gonna be very popular bands. And it was true: Free music just kind of unrolled the carpet for people to come and hear this band. It was a free show, so it was perfect advertising.

By that time, Haight-Ashbury was really filled up with people, and it was getting to be a bit of a problem. A lot of hippie entrepreneurs had set up shop on Haight Street and thereabouts. Everything was so pleasant and social and congenial. It was really lovely. It was a great time. And I wish it could have lasted longer, but it got overwhelmed by late '68. By 1969 things were getting really jammy down there.

Jim was very quick. He obviously found somebody with a door open and just charged up their stairs and leaned out the window. That would be my guess. It could well have been the Straight Theater. He just found a way. Jim was nothing but ambitious, really. His talent shows in his work, but his ambitiousness was powerful, and he could insert himself into just about any situation and get good pictures.

Jim was so intent on his target that you really didn't wanna get between him and whatever it was he was trying to get to, because Jim would just wiggle his way through the crowd or jump the fence to get the picture that he wanted. And now we have these amazing pictures. We used to be mad at him, and now we're pleased.

—Mountain Girl

Jerry Garcia, last concert on Haight Street.
March 3, 1968.

Mickey Hart, last concert on Haight Street. March 3, 1968.

Bill Kreutzmann, Phil Lesh, Bob Weir, and unknown flute player, last concert on Haight Street. March 3, 1968.

When the Grateful Dead played on Haight Street on March 3, 1968, it was their farewell to the Haight. They had been busted [for drug possession in October 1967]; Jerry ducked the bust, thanks to the lady across the street, but it was like, "Maybe we should go to the country, get the hell outta town." The band starts playing literally in the middle of Haight Street, and it's just a people magnet: Obviously the word had gone out! They're on the rooftops and in the windows, and then of course the street itself, and where does Jim Marshall end up? Literally on the floor of the flatbed shooting up! It's never been clear to me exactly how much that was preplanned. Rock said they basically sort of slithered in on a flatbed truck to play.

—Dennis McNally

Phil Lesh and Bob Weir, last concert on
Haight Street. March 3, 1968.

Bill Kreutzmann and Phil Lesh, last concert on Haight Street. March 3, 1968.

Grateful Dead, rooftop view from Straight Theater, last concert on Haight Street. March 3, 1968.

66

We did not know how to behave. So when it came time for us to do photo shoots, we did our best to confuse the whole damned thing—successfully, I might add. Our mood was: We're not gonna behave for you just because you're here taking pictures. Every photo shoot turned out to be a comedy routine. We were gonna be the Grateful Dead, and that's who we were at that time. It was so much fun.

—Donna Jean Godchaux-MacKay

Proof sheet, Grateful Dead studio shoot at Le Club Front, San Rafael, 1977.

Proof sheet, Donna Jean Godchaux and Keith Godchaux, Le Club Front, San Rafael, 1977. The four images at bottom right are of sound engineers Betty Cantor-Jackson and Bob Matthews.

I remember thinking like, This is your band photo? Really? This is what you wanna show the world? You could tell they probably gave him all of ten minutes.

—Justin Kreutzmann

The hand gesture Pigpen is giving is a theme throughout this book and has an explanation. . . .

The gesture title is "The Meat Shot." I don't know where the term or action originated, but that could be an interesting research project. But is it glaringly obvious what the gesture means (in a still photo), as compared to a photo of giving someone the finger? If someone gives you the meat in person, it's much more obvious, as it may include simulated masturbation with the hand/hands lower down. . . . I venture a guess that it evolved from one person like Pigpen making the full gesture in fun, as a "fuck you" to a photographer . . . to eventually everyone doing it when they couldn't think of a new way to pose for a group photo. The final insult was of course Weir doing the massive "fire hose" gesture.

—Rosie McGee

Pigpen, backstage at Winterland, Trip or Freak Psychedelic Art Exchange. October 31, 1967.

Jerry Garcia, Woodstock, Bethel, New York. August 16, 1969.

Jerry's muttonchops lasted about four months. I think he discovered one day that there was some food residue building up in there—I don't know why he wanted them in the first place. Jerry hated shaving, and he had a very heavy beard. It grew fast. It was black. There was a lot of it. And you can see how dense it was.

When I first knew Jerry, he shaved every day. And then suddenly one day he stopped and said, "I'm done. I'm not gonna shave every day anymore. I'm just gonna let it grow." Everybody kind of gasped and said, "OK." His beard covered a lot of his face, and it made him more comfortable. But he didn't like the way he looked in pictures. I think he liked having his face showing, but he thought he was ugly. He would make comments about himself. And so he liked the beard because it covered up his perceived flaws. It made life so much easier. It came and went and came and went over and over.

—Mountain Girl

Jerry Garcia and Pigpen, 1967. Jim shot photos of Janis Joplin as well as the Dead (who dosed him with LSD that day) at this rare studio session.

Mickey joining the band did something for the Grateful Dead sound that was so astonishing. Everybody noticed it, to have that extra beat. And Mickey, of course, plays differently from Billy. It added a whole dimension, and people kind of flipped over it. The band realized that that was doable, and they were gonna do it. So that became the way it was gonna be from then on. They suddenly realized the second drummer gave them such a bigger sound. I think it pushed the musicians into a new way of playing their stuff, and it really, really worked for the audiences.

—Mountain Girl

Grateful Dead, Straight Theater. September 29, 1967. A group of local artists fixed up the abandoned Haight Theater and renamed it the Straight. The city initially denied them the dance permits required to hold concerts, but they went ahead, billing the events as dance classes.

I never understood the Grateful Dead until one day Santana opened for them in Tacoma [on August 26, 1988]. I stuck around and listened to them; that was the first time I got it. It's like I had been looking at it with the wrong eyes, listening to it with the wrong ears. It reminded me of being in Paris—I went to the Louvre to see the *Mona Lisa*. I was way in the back of a huge crowd, and without even remembering how I got there, I was in the front. It was a spiritual experience for me.

And also, as I got older I realized how much of a musical snob I was; that was getting in the way of me appreciating the Dead as well. I used to play in folk-rock bands when I was in high school. I had a band that played "High Flying Bird." I had some people in high school teach me where this music from the Dead and the Airplane came from. So I actually had some schooling in it, but I didn't connect.

I took lessons as a kid at Mickey Hart's father's drum store in San Carlos, and Mickey was always playing on the [practice] pad. He was a rudimental champion, so when he joined the Dead, I was surprised. I was like, how's that work? Well, he got it, whereas I would've been playing a harder backbeat or something, because I was taking funk lessons from a guy there. This is more like jazz. Later, when I got deeper into Jack DeJohnette and really studied that stuff with Miles, I saw that the Dead were taking the same approach: wide open. Later I saw people like Branford Marsalis or Don Was or John Mayer playing with the Dead; every one of 'em comes out saying they're a better musician for the experience.

—Michael Shrieve

Mickey Hart, KQED-TV *A Night at the Family Dog* special, Family Dog on the Great Highway. February 4, 1970.

Mickey Hart, Northern California Folk-Rock Festival, Santa Clara County Fairgrounds, San Jose. May 18, 1968.

Grateful Dead, KQED-TV *A Night at the Family Dog* special,
Family Dog on the Great Highway. February 4, 1970.

Gary Duncan and Jerry Garcia, KQED-TV *A Night at the Family Dog* special, Family Dog on the Great Highway. February 4, 1970.

Pigpen, KQED-TV *A Night at the Family Dog* special, Family Dog on the Great Highway. February 4, 1970.

Bill Kreutzmann, backstage at Winterland, 1971.

Mountain Girl, Jerry Garcia, and Neil Young, backstage at a
Crosby-Nash concert, Royce Hall, University of California,
Los Angeles. October 11, 1971.

Jerry Garcia and Bob Weir, Lindley Meadow, Golden Gate Park.
September 28, 1975.

He had a camera and not a guitar, but he was a peer with all those guys. Nobody treated him like an outsider looking in. Everyone's giving him shit just like everybody else. He is just part of the gang. He always knows where the camera is, of course.

I'm curious to know when Jim Marshall became so famous that bands wanted him to take their photo, to say that they had their photo done by Jim Marshall. When did that switch happen? Going from being one of the gang to being as famous as, or more famous than, some of these bands? Everybody wanted that iconic Jim Marshall photograph.

Those dressing rooms in the 1960s and 1970s weren't that big, and those recording studios weren't that big. There weren't a ton of people there taking photos. Jim allowed you to get a sense of what it was like. You just didn't feel like people's guards were up. It felt natural.

You had to be there, and you had to be the right person to be there. And Jim was. That's such a gift.

There's the music, and then there's the visual. I'm a pretty visual guy, so to have the images of these people almost means as much to me as playing their records.

—Justin Kreutzmann

Jerry Garcia, Bob Weir's house, 1976.

Phil Lesh, Lindley Meadow, Golden Gate Park.
September 28, 1975.

Bob Weir, Lindley Meadow, Golden Gate Park.
September 28, 1975.

Jerry Garcia, Jerry Garcia Band (and later Grateful Dead) rehearsal and recording space, 20 Front Street, San Rafael, 1977.

Grateful Dead, across Geary Street from the Fillmore Auditorium, 1966.

Grateful Dead, Sky River Rock Festival, Betty Nelson's Organic Raspberry Farm, Sultan, Washington. September 2, 1968.

Jerry Garcia, Newport Pop Festival, Orange County Fairgrounds, Costa Mesa. August 4, 1968.

Pigpen, Artists Liberation Front Free Fair in the Panhandle. October 16, 1966.

Phil Lesh, Sky River Rock Festival, Betty Nelson's Organic Raspberry Farm, Sultan, Washington. September 2, 1968.

Pigpen and Phil Lesh, on KPIX-TV's *POW!* show, San Francisco, spring 1967.

Jack Casady and Bob Weir, Northern California Folk-Rock Festival, Santa Clara County Fairgrounds, San Jose. May 18, 1968.

Jim wasn't just an observer. When he would show up to take pictures, he was almost like a band member in some way; Jim became part of the scene. I imagine that's probably what happened when he went to photograph the civil rights movement too.

—Jorma Kaukonen

Jerry Garcia and Wolf, Jerry Garcia Band (and later Grateful Dead) rehearsal and recording space, 20 Front Street, San Rafael, 1977.

Phil Lesh and Rosie McGee, Northern California Folk-Rock Festival, Santa Clara County Fairgrounds, San Jose. May 18, 1968. Jim Marshall is reflected in Lesh's sunglasses.

ORIGINS

BY DAN SULLIVAN

So what kind of Deadhead are you?

Are you an old Head who was on the scene back when the Dead were just another neighborhood band in the Haight? Or a youngster, a John Mayer fan who caught the bug after seeing your first Dead & Company show in the 2020s? A hardcore psychedelic ranger, dosed to the gills for most every show you saw, or a clean and sober Wharf Rat? An enthusiastic tape trader, or even a taper yourself?

Maybe you caught one or two shows a year, whenever the traveling circus came to your corner of the world. Or perhaps the band's touring schedule was the organizing principle of your life for a spell, and the community you found on the road transformed your existence and set you on an entirely new path.

Maybe it's all about the music for you: knowing the band's vast repertoire inside and out, calling tunes with your friends and scribbling set lists in the dark, puzzling over a brand-new tune (Is that one of theirs, or a cover?), and screaming deliriously when the band breaks out an old favorite that hasn't been played live in many years.

Do you listen pretty much exclusively to Dead-related music, or are you an aural omnivore, for whom the Dead are just one of many abiding musical passions? And what's your Grateful Dead origin story?

If, like me, you are really into the Grateful Dead's own origin story, especially its role in the birth and development of the global youth counterculture, you are in for a real treat.

When Jim Marshall passed away in 2010, he left everything to Amelia Davis, his close friend and assistant for the last thirteen years of his life. Since then, Amelia and her wife, Bonita Passarelli, have worked tirelessly to celebrate his life's work and solidify his legacy as one of the great photographers of the twentieth century. They have secured Jim's archive of more than one million images, built a website and multimedia presence, aggressively protected Jim's copyright, mounted gallery shows across the United States and Europe, produced the award-winning documentary *Show Me the Picture: The Story of Jim Marshall*, and published seven beautiful books.

Now comes this eighth book, a deep dive into Jim's Grateful Dead photography. When my friend Amelia asked me to contribute an essay offering one Deadhead's personal perspective on these images, I jumped at the chance. Because this one is for us—the fans.

Every Deadhead has an origin story. In many ways, mine is typical for those who got on the bus in the late 1970s and early 1980s: Friends turned me on to the band in college, and I didn't really "get" them at first, but then a buddy took me to my first show, and I was hooked.

But there is just a bit of a twist.

I grew up in Detroit during the 1960s, crazy about music and absorbing all the amazing sounds around me: Motown, of course, and the proto-punk of the MC5, but also the wide variety of pop purveyed by two of the country's very best Top 40 AM radio stations. And, crucially, my older siblings' record collections: the Beatles, the Stones, Cream, Alice Cooper, King Crimson, and more. So I consumed a steady diet of classic pop, R & B, and rock.

In January 1973, halfway through seventh grade, my dad's job took us to Europe, and I got heavily into underground German music: Can, Cluster, Klaus Schulze, Tangerine Dream, Neu!, Harmonia, and most of all Kraftwerk. This was keyboard- and synthesizer-based music, rooted in free-form psychedelia and the European avant-garde classical tradition, and the musicians were consciously avoiding blues-based rock forms.

In 1975 we moved from Frankfurt to London, and the inputs changed again. Being a teenage music nut in mid-'70s London was heaven. Prog rock was at its peak, and over the next few years I became a big fan of musicians like

Jethro Tull, Yes, Genesis, Pink Floyd, Traffic, Focus, and Peter Gabriel.

The UK was also experiencing a second wave of psychedelia. Underground chemists were churning out heroic quantities of high-quality LSD, and hashish was strong, cheap, and plentiful. The music-festival scene was flourishing, thousands of freaks were taking to the road, and hippie acts like Gong, Steve Hillage, Here & Now, Man, Hawkwind, and the Pink Fairies provided the perfect spaced-out soundtrack. Right around this time I tried my first hit of Orange Sunshine. Things were opening up.

And, of course, there was the punk-rock explosion. I loved the high energy, three-chord, do-it-yourself spirit of punk—definitely a Detroit thing. But punk was also a violent rejection of the music I loved the most, especially European progressive and psychedelic rock.

In September 1978, things got even more confusing when I moved back to America and started college at Michigan State University. But America wasn't the same place I remembered from 1972, and I certainly wasn't the same either.

I roomed with my high school buddy Jon. We were lonely at first, and profoundly disoriented, and deeply unhappy. Walking across campus that first weekend we were astonished to see dozens of drunken students stumbling around in sheets and vomiting copiously into the bushes. Someone later explained they were going to toga parties. *Animal House* had come out a few weeks earlier, just one of many cultural references that were totally beyond us.

But lo and behold, it turned out most of my dormmates were just as nuts about music as I was. The countless hours spent hanging out and sharing favorite records turned out to be a great way to get to know one another and for me to ease my way back into US culture.

One band my new friends loved was the Grateful Dead. I hadn't really heard much Dead music before arriving at MSU, mostly radio tracks like "Truckin'" and "Casey Jones." But I did know a little about the Bay Area psychedelic ballroom scene from which the Dead emerged, and its seminal role in the global youth counterculture with which I identified. And I'd read Tom Wolfe's *The Electric Kool-Aid Acid Test*, so I understood the Dead's connection to Ken Kesey's Merry Pranksters, and the cultural through line (personified by Neal Cassady) from the '50s Beat movement to the '60s San Francisco hippies.

The European progressive rock and psych I loved was head music: very strong jazz and classical influences, often keyboard based, musically and sonically complex. At live shows, not a ton of dancing went on. Folks generally stayed seated, smoking hash joints, concentrating on the music, and tripping out.

West Coast psych struck me, at least initially, as body music: more blues and folk based, guitar forward, dance oriented, and not especially trippy, in the headphone-worthy sense. Plus, I had no real understanding of what we might today call the Dead's Americana roots: the self-written ballads and the covers of classic country, folk, and blues numbers.

Their first album I really grew to know and love was the self-titled 1971 double live album popularly known as *Skull and Roses*. The big track for me was "The Other One," a side-long opus with mind-melting jams and lyrics about Neal Cassady: a chronicle of the Dead's own psychedelic origin story.

On August 27, 1980, my buddy Gopal took me to my first Dead show, at Pine Knob Music Theatre in Clarkston, Michigan. We had great seats down front, the show was excellent, and I finally fully understood what was going on musically. It struck me that this was a perfect blend of head and body music. And that I was home.

Within a year, inspired by the do-it-yourself ethos of punk rock, Gopal and I started a band with Jon and another dormmate named Crazy John. We played early Pink Floyd, Dylan, and Velvet Underground tunes—and especially songs associated with the Dead, both originals and the blues, folk, country, and bluegrass tunes that were a key part of their vast repertoire. Learning to play and sing those songs opened me up to vast new worlds of American roots music, all of which I love to this day.

I went on to see more than fifty Dead shows. And my love of the Grateful Dead and passion for the Bay Area music scene—not to mention a transcendent psychedelic experience at my first West Coast show, during the Dead's twentieth-anniversary run at Berkeley's Greek Theatre in June 1985—played a big part in my decision to move out to Oakland in 1987.

So that's my Dead origin story. As is the case for many of you, the Dead have been a big part of my life—a bit of an organizing principle, in fact—for decades now.

However, very few of us were there when Jim Marshall started shooting the Dead in early 1966. And plenty of us have a real fascination with what it must have been like to

Mountain Girl (holding Sunshine Kesey), Bill Kreutzmann, and Jerry Garcia, memorial concert for Robert F. Kennedy, Golden Gate Park. June 9, 1968.

witness the Dead's own origins, in real time. Here's your chance.

This book offers an unprecedented deep dive into some of Jim's thousands of Grateful Dead images, most of which have not been seen since Jim first developed a particular roll of film; decided what, if anything, to print; and filed the contact sheet away in his meticulously cataloged archive.

These photos are historically significant visual records of the Dead's origins. Like all of Jim's work, they are of the highest aesthetic and technical quality. And they have an uncanny way of putting us right in the middle of the action.

Partly this was a function of his technical choices: Using available light and compact, quiet Leica cameras helped Jim blend into the scene. Jim also had an incredible eye for composing a picture, which he did full frame, in real time, very rarely cropping in the darkroom—a quality that shines through in the contact sheets included here.

But perhaps the biggest factor was the trust Jim always engendered in his subjects. Remember, he was a participant-observer at these events, and "family" to all the relatively unknown hometown San Francisco bands he was documenting at the time, including the Grateful Dead. All of this lends an amazing warmth and intimacy to the work.

We are left with perfect time capsules for those of us current fans who were not around—or in many cases, not even born—at the time Jim made these images.

So many of these photos blew my mind when I first saw them. For example, the gorgeous color shots of those early (1966–67) free concerts in the Panhandle. They give me an almost tactile and olfactory sense of what it was like to be hanging out in the park on a Saturday afternoon,

waiting for the local freaks to hop up on the flatbed truck and start wailing away. I can smell the eucalyptus trees, feel the grass beneath my feet, and sense the foggy breeze blowing up from Ocean Beach. Next best thing to having been there myself.

The Panhandle concert photos also illustrate another thing about Jim's Grateful Dead images: While he did travel with the band on occasion, for example to the Woodstock, Monterey, Sky River, and Newport Pop music festivals, the large majority of these shots were made right here in the Bay Area. And San Francisco—its neighborhoods, music venues, Victorian architecture, parks, and people—is just as much Jim's subject as the Grateful Dead are. What a visual treat for those of us fortunate enough to know and love this special place.

I was also amazed to see the series of images that show Jerry Garcia jamming with Traffic—Steve Winwood, Jim Capaldi, and Chris Wood—on Monday, March 18, 1968. This was at a free benefit concert for striking staff members at KMPX-FM, the country's first underground free-form radio station. I had read of how members of the Dead met Traffic at the airport when they arrived to start their first American tour, dosed them with Owsley's finest, and hung out extensively during Traffic's ten-day stay in San Francisco. During that time, Traffic played both the Fillmore and Winterland. Now we have visual evidence of what had long been only a rumor: They also played that strike benefit on the streets of San Francisco, with a clearly delighted Jerry Garcia sitting in.

The book also contains visual evidence of another long-rumored but seemingly apocryphal event. At midnight on New Year's Eve 1968, during the balloon drop, two freaks clad only in diapers and sashes (one reading "1968" and the other "1969") rode on horseback into the crowd, right down in front of the Winterland stage. When I came across a few color slides of this amazing moment a few years ago, while doing some archival work for Amelia and Bonita, my head just about exploded. Turns out the images had been published at least once before, in a 1995 special Jerry Garcia/Grateful Dead commemorative edition of *American Photo* magazine. But for most of you, this will be your first chance to see the origins of the band's wonderful tradition of spectacular parades during shows marking New Year's Eve, Mardi Gras, and Chinese New Year.

One more little-known moment in time, captured for posterity by Jim Marshall: On Sunday, June 9, 1968, the Dead and Jefferson Airplane attempted to put on a free memorial concert/wake in Golden Gate Park for Robert Kennedy, who had been slain in Los Angeles three days earlier. But the cops shut them down, citing their lack of a permit and the (apparently completely bogus) competing reservation by a pack of three hundred Cub Scouts for the Speedway Meadow space.

Jim was there and captured the whole sad scene, with Garcia, Phil Lesh, Bob Weir, Bill Kreutzmann, Mountain Girl, manager Rocky Scully, and others pleading with the cops—some on horseback—as the disappointed crowd of three thousand kids stood by.

Like Jerry jamming with Traffic, and those near-naked hippies riding horses onto the floor of Winterland, this historic happening was much discussed and somewhat documented at the time, and it lived on in foggy, tribal folk memory. But most Deadheads alive today have never heard of it.

What a treat to relive this and so many other incredible moments, and to get a real sense of the Grateful Dead's own origin story, through Jim Marshall's eyes. I only wish the irascible old man were still around to answer the many questions these pictures raise in my mind.

This book is Jim's gift to all of us Deadheads. No matter what kind of fan you might be, no matter when you got on the bus, whatever your own Grateful Dead origin story: I'm sure it will surprise and delight you.

Phil Lesh, Jack Casady, Mickey Hart, and Bob Weir, memorial concert for Robert F. Kennedy, Golden Gate Park. June 9, 1968.

Opposite and this page, top: Hippie on horseback ("Baby 1969") rides into crowd at midnight, New Year's Eve, Winterland. December 31, 1968.

This page, bottom: Bill Graham, New Year's babies 1968 and 1969, and Bob Weir, New Year's Eve, Winterland. December 31, 1968.

This page, top: Bill Graham, now-naked New Year's babies, New Year's Eve, Winterland. December 31, 1968.

This page, bottom: Bill Graham (center, in yellow shirt and cap), the Grateful Dead, and Carlos Santana (to left of Bob Weir), New Year's Eve, Winterland. December 31, 1968.

Opposite: Midnight balloon drop, New Year's Eve, Winterland. December 31, 1968.

Steve Schapiro and Baron Wolman,
KMPX-FM radio strike, Green Street
at the Embarcadero. March 18, 1968.

Pioneering disc jockey Dusty Street,
KMPX-FM radio strike, Green Street at
the Embarcadero. March 18, 1968.

Traffic with Jerry Garcia, KMPX-FM radio strike, Green Street at the Embarcadero. March 18, 1968.

Steve Winwood and Jerry Garcia, KMPX-FM radio strike, Green Street at the Embarcadero. March 18, 1968.

Opposite, top: Jerry Garcia with Chris Wood and Jim Capaldi of Traffic, KMPX-FM radio strike, Green Street at the Embarcadero. March 18, 1968.

Opposite, bottom: Steve Winwood and Jerry Garcia, KMPX-FM radio strike, Green Street at the Embarcadero. March 18, 1968.

This page: Audience at Traffic concert with Jerry Garcia, KMPX-FM radio strike, Green Street at the Embarcadero. March 18, 1968.

Spencer Dryden once said something to the effect that all the people around the country that felt out of step came to San Francisco to be out of step together. It's a great line, and it applied exactly to Bill and Jim, even though they weren't freaks.

—Dennis McNally

Bill Graham outside the Fillmore Auditorium on October 9, 1966. Per the beautiful poster, this triple bill was originally scheduled for Friday and Saturday, October 7–8, at Winterland. Graham moved it to the smaller Fillmore (and added this Sunday-afternoon show) because of concern about low ticket sales. The largely African American neighborhood was in turmoil after police had shot a Black man the weekend prior.

Members of the Grateful Dead, the Paul Butterfield Blues Band, and Jefferson Airplane jamming at the Fillmore Auditorium. October 9, 1966.

Collaborations like Grateful Butterplane happened fairly often—we'd get two or three acts all wanting to work together. And it was always good to see Butterfield. He always had some new stuff. And Bloomfield. They always had new material musically. They were very active. So was the Airplane.

—Mountain Girl

Jack Casady, Jerry Garcia, Elvin Bishop, Spencer Dryden, and Jorma Kaukonen jamming at the Fillmore Auditorium. October 9, 1966.

Grateful Dead, across Geary Street from the Fillmore Auditorium, 1966.

Grateful Dead, Sky River Rock Festival, Betty Nelson's Organic Raspberry Farm, Sultan, Washington. September 2, 1968.

Newport Pop was when things started to get really important. The band wasn't having quite as much fun. It got more serious. As the audiences got bigger, the band got more serious about delivering well, and Jerry especially was concerned with making sure that everybody knew their parts and could do it well.

Between Jerry and Phil, they got their way pretty much most of the time. Phil stopped being silly after a while and got very serious about everything.

—Mountain Girl

Jack Casady, David Crosby, and Phil Lesh, Newport Pop Festival, Orange County Fairgrounds, Costa Mesa. August 4, 1968.

Susila was a do-all girl. She was a seamstress. She had a clothing shop, Kumquat Mae, that she ran in San Anselmo. She was just a very busy person. Susila always liked to have three or four things happening around her. And she got a lot done.

She basically invented concert merchandising by creating T-shirts and starting the band's merch business.

That is true. When she figured out she could silk-screen a T-shirt, that was the beginning of a whole bunch of stuff. But before that, we were doing one-offs. We were painting stuff and selling it at Susila's shop in San Anselmo.

A lot of us made stuff. Sue Swanson and I and a few other ladies made stuff to sell there and sort of helped her run it from time to time. It was a great place to hang out . . . away from wherever the band was living at that time. It gave us another place to be that was very friendly and nice.

—Mountain Girl

Bill Kreutzmann and Susila Ziegler in the Panhandle, 1966.

My favorite Jim Marshall photograph of the Grateful Dead is one I saw at the office of Eileen Law, who started working for the Grateful Dead when they were the Warlocks. She had this photo of Pigpen and Jerry where Pigpen's looking this way, and Jerry's looking this way, and they're cutting each other's faces off. It was the most remarkable frame and always just struck me as such an amazing juxtaposition. You just never see people like that in a photo. That photo always jumped out at me as being really a unique framing of those two guys, sort of on top of each other.

—Justin Kreutzmann

Pigpen and Jerry Garcia, Newport Pop Festival, Orange County Fairgrounds, Costa Mesa. August 4, 1968.

Al Kooper, Jerry Garcia, and Jack Casady, the Matrix. January 20, 1969.

A lot of stuff happened in the Panhandle; it was a very active place. It wasn't hard to get permission from the city to have a gathering there. It's a wonderful spot.

At the Artists Liberation Front Free Fair in the Panhandle, the Dead had a stage. They advertised, and half of San Francisco came to that one. It spilled out into the streets on both sides. It was a really good-sized crowd there. Luckily, they had gotten a good sound system for that concert too. So it was actually bouncing off the buildings in the background. It was pretty loud—loud and good. The band really played hard for that one, 'cause there were so many people there.

Look at those interesting speakers. They look like washtubs with stuff inside. It was another reason to gather and have a whoop-de-doo. You can see how cold it is. Everybody's wearing their sweaters and jackets, even though the sun is shining.

Look at how many people are there! They even built a little stage out of what looks like four-by-fours and about six pieces of wood. It's interesting to see how this was growing and choosing to grow, because look at the number of people there. These are happy crowds, happy days.

—Mountain Girl

Grateful Dead, Artists Liberation Front Free Fair in the Panhandle. October 16, 1966.

Jerry Garcia, Artists Liberation Front Free Fair in the Panhandle.
October 16, 1966.

Bill Kreutzmann, Phil Lesh, Bob Weir, and Jerry Garcia, Artists Liberation Front Free Fair in the Panhandle. October 16, 1966.

Freewheelin' Frank was an old, old friend of the Pranksters. We met him probably right before this, in a little scene at the Prankster get-together.

The Hells Angels—the friendly ones—hung out with us quite a bit at the house and at shows, and they worked on us to get backstage passes, which they got. They also served as sort of riot police for us when we needed them. They helped take people out that needed to leave the room, who were getting too . . . flippy. They were eyes and ears for us for quite a long time. All they wanted was just to go to the shows and be acceptable.

—Mountain Girl

Jerry Garcia, Freewheelin' Frank (leaning on amplifier), and neighborhood folks, Artists Liberation Front Free Fair in the Panhandle. October 16, 1966.

This is a beautiful photograph of Danny Rifkin when he was young and beautiful. Look: His hair is combed! Hard to believe! And Jerry's wearing some old sweater he had.

—Mountain Girl

Danny Rifkin and Jerry Garcia in the Panhandle, 1966.

Jerry Garcia, Phil Lesh, and Bob Weir, New Year's Eve, Winterland. December 31, 1968.

Grateful Dead, New Year's Eve, Winterland. December 31, 1968.

Grateful Dead, New Year's Eve, Winterland.
December 31, 1968.

Phil Lesh and Bob Weir, New Year's Eve, Winterland.
December 31, 1968.

MORE JERRY THAN HYDE
BY BLAIR JACKSON

Folks who knew Jim Marshall pretty well or worked with him a lot probably have stories like mine of arriving at his old Union Street apartment in San Francisco and being greeted by him pointing a pistol down the stairs at me. Of the lunches where I invariably spent part of the meal apologizing to the waitress or waiter after he'd insulted them or loudly regaled me with some racist/antisemitic/homophobic rant that was all bluster and show. "Don't pay any attention to him," I'd say, trying to keep things light. "He's a little crazy. He doesn't mean it." And Jim would chuckle and turn it down a few notches, sometimes even apologizing and always leaving a big tip (though I always paid for the meal).

But all things considered, Jim was much more Jekyll than Hyde. And working with him often over the years—first when I was a writer/editor at the Bay Area–based music magazine *BAM* in the late '70s and early '80s, then through the nine-year life of the Grateful Dead fanzine I put out called *The Golden Road*, and finally when I used his photos for books I wrote about the Dead—was always special and memorable. Beneath the gruff exterior, he was a real sweetheart. He was nothing but helpful and kind to me, suggesting photos I might want to use or allowing me to sit by his side for long stretches poring over his meticulously organized proof sheets, selecting photos I liked.

He had so many iconic photos, of course. It was always a thrill when, going through his proof sheets, you'd suddenly run across, say, the famous shot of a smiling Janis Joplin, Southern Comfort bottle in one hand, lounging backstage at Winterland, the image outlined in grease pencil on the proof sheet, as all his "keepers" were. But the truth is everything around that shot was great too. No lie: 98 percent of what's on those thousands of proof sheets is *phenomenal*. He just had that eye and that instinct and that ability to unobtrusively capture people's souls with his camera. Especially for *The Golden Road*, I was always on the lookout for shots that I hadn't already seen everywhere. I'd say something like "Grateful Dead, closing of the Fillmore West" or "Grateful Dead, Woodstock," and he'd whip out a stack of proof sheets and hand me a loupe. I'd be stopped in my tracks by some particularly cool image, and he'd casually say, "Oh, you like that? I've never had that printed! You think it's good?" Um, yeah, Jim! And the icing was that he charged us only fifty dollars a shot because he liked our unpretentious little magazine.

I think the last time I saw Jim was at the opening of an exhibit showcasing his outstanding photography of the early 1960s civil rights movement. It was deep, moving, and insightful. And though I couldn't tell you exactly why, it was all so clearly the work of the great artist/documentarian/genius Jim Marshall; truly one of a kind!

Grateful Dead proof sheet, 1967.

Grateful Dead proof sheet, 1967.

His art is remembered a lot more than his rough and rowdy ways. There's a certain automatic reaction when people talk about Jim Marshall, you know? It's the guns and the drugs—but man, those pictures are just something else.

—Dennis McNally

Bill Kreutzmann, Sky River Rock Festival, Betty Nelson's Organic Raspberry Farm, Sultan, Washington. September 2, 1968.

Jim's best stuff, to me, is the stuff he took of people in dressing rooms or backstage, where he captured a moment or a personality. You could compare Jim to a Weegee or a Garry Winogrand. He falls into that category for me, and he's good at it.

—Dave Getz

Jim Marshall photographing Jerry Garcia reflected in a mirror, backstage at Winterland, Trip or Freak Psychedelic Art Exchange. October 31, 1967.

Mickey Hart, Jorma Kaukonen, and Bill Thompson, Northern California Folk-Rock Festival, Santa Clara County Fairgrounds, San Jose. May 18, 1968.

Phil Lesh and Rosie McGee, Northern California Folk-Rock Festival, Santa Clara County Fairgrounds, San Jose. May 18, 1968.

Jerry Garcia and Bob Weir, Northern California Folk-Rock Festival, Santa Clara County Fairgrounds, San Jose. May 18, 1968.

I wasn't a Deadhead, but I was kind of a Bob Weir groupie. My parents went to the same country club as his parents. So we met early on, and I followed him around, like an annoying little sister to a big brother kind of thing.

Jim Marshall asked me what I saw in Bob Weir. That was early on when Bob was really young and he had long hair. He looked like a girl. "What do you see in him?"

—Pattie Spaziani O'Neal

Above and opposite: Bob Weir, Northern California Folk-Rock Festival, Santa Clara County Fairgrounds, San Jose. May 18, 1968.

Jerry Garcia, backstage at the Matrix.
January 20, 1969.

Phil Lesh, Sky River Rock Festival, Betty Nelson's Organic Raspberry Farm, Sultan, Washington. September 2, 1968.

Mickey Hart, Ken Kesey, Allan "Gut" Terk, Rock Scully, and Danny Rifkin, Newport Pop Festival, Orange County Fairgrounds, Costa Mesa. August 4, 1968.

Ram Rod, Phil Lesh, Mickey Hart, and Bert Kanegson, Sky River Rock Festival, September 1968.

Renée LeBallister dancing, KQED-TV *A Night at the Family Dog* special, Family Dog on the Great Highway. February 4, 1970.

Bill Kreutzmann, backstage at Winterland, 1971.

It must have been about '63 when I met Jim Marshall. We got along pretty well, but Jim was supercompetitive. He was a whole different person from me, like apples and kumquats. Jim was a gonzo, gun-totin', coke-sniffing journalist.

Jim was really ambitious and really hardworking. He had a work ethic that was second to none, which I couldn't even begin to achieve. I did work pretty hard getting the stuff I did get, but nothing like him.

Jim would kick down a dressing-room door to get a picture. I was just the opposite. To me, taking a camera out and putting it in somebody's face was intrusive. That's why I didn't do candid, backstage stuff: To me, it was kind of an invasion of privacy. I could never do that. I had to have an assignment to do it.

We were two totally different people. Jim was like a wolf, and I was like a rabbit.

Jim had a side of him that was really great and loyal and all that. And he had a darkness, which dominated his life.

—Herbie Greene

Bill Kreutzmann, backstage at the Fillmore Auditorium, 1966.

Jim was the high-water mark. When it was a Jim Marshall photo, you knew this was gonna be good. You can look at any band: The Jim Marshall shot is the iconic one. Even if you didn't know it was him, you've seen that photo. I don't know if it was his winning personality or just the tenacity to get in your face and get the shot. But he always managed to get those moments that nobody else could capture.

And people let him in. Trust me, I know: This is not a band that loves having a camera pointed at them, or loves having a camera in their dressing room. You have to be a certain kind of person, and you have to really know how to pick your moments—and know when to maybe not pick a moment, 'cause you can ruin a good moment with the Grateful Dead by pulling a camera out. He always scored.

He was one of those people on the scene—one of those Bay Area guys who were always there. I was pretty young when he was shooting a lot of the Grateful Dead stuff. I would've just been the kid tagging along. I would've loved to pick his brain about how he got those shots and other things. But he's definitely been an inspiration.

I can't tell you the number of Jim Marshall photos I've been given as birthday gifts.

—Justin Kreutzmann

Bill Kreutzmann, 710 Ashbury, 1967.

Bill Kreutzmann and Phil Lesh, Newport Pop
Festival, Orange County Fairgrounds,
Costa Mesa. August 4, 1968.

Mickey Hart, doorway of the
Fillmore Auditorium, 1968.

JIM MARSHALL
AND
THE GRATEFUL DEAD

BY PETER RICHARDSON

In 1967, the San Francisco hippies were ready for their close-up.

In January of that year, some twenty thousand people flocked to Golden Gate Park to celebrate a new and ecstatic form of youth culture. "A Gathering of the Tribes for a Human Be-In," as the event was billed, featured live music as well as poet Allen Ginsberg, LSD advocate Timothy Leary, and political activist Jerry Rubin. For news outlets, the sheer spectacle of the Human Be-In was irresistible. "The media delighted in the infinitely photogenic Be-In," Todd Gitlin recounted in his history of the 1960s. "Whatever this strangeness was, it was certainly A Story."[1] Media coverage of the San Francisco hippies mounted for months and then peaked during the Summer of Love, when seemingly every magazine and news organization reported on the Haight-Ashbury scene. Writing for *The Nation* magazine, Bay Area academic Theodore Roszak called that scene "the counterculture," and the name stuck.

If the intensity of the media coverage was remarkable, so was its selection and emphasis. The focus on drugs and politics stemmed in part from two major stories the previous year. Congressional hearings highlighted the dangers of LSD, leading California to ban the drug in October 1966. Meanwhile, Ronald Reagan's gubernatorial campaign was trying to trigger a moral panic about students at the University of California, Berkeley. At a press conference in San Francisco, Reagan went on the attack. Quoting a report from the Committee on Un-American Activities in California, which described a dance in Harmon Gym, Reagan concluded that the combination of rock music, marijuana, and freestyle dancing was part of the international communist conspiracy.

As reporters churned out their copy, most of them missed a significant story unfolding right under their noses. A small group of San Francisco hippies was transforming rock music and its live performance. When the Beatles played Candlestick Park in 1966, their set reflected the rock conventions of that time. The musicians wore matching suits, played eleven songs in thirty-three minutes, and were accompanied by screaming teenyboppers. In the ballrooms across town, however, the Grateful Dead played jams that lasted longer than the Beatles' entire performance. Bathed in pulsating light, the psycho-activated audiences were more likely to dance than to scream. That experience, and the psychedelic posters that promoted it, became the San Francisco counterculture's signature.

That development wasn't lost on Ralph J. Gleason, the veteran music journalist at the *San Francisco Chronicle*. Indeed, Gleason used his column to champion the city's fledgling rock scene. When combined with the efforts of promoter Bill Graham and FM radio pioneer Tom Donahue, Gleason's endorsement was especially significant. Music executives descended on San Francisco and offered recording contracts to local bands. Shortly after their LPs were released, Atlantic Records president Ahmet Ertegun described the San Francisco music scene as sensational. "No other city has anything like it," he said. "Something like fifteen out of the first nineteen albums recorded by San Francisco bands made the bestseller charts. There's something different about the San Francisco bands, some mystique."[2] No longer a local story, those bands—and the culture that supported them—turned San Francisco into a global rock capital.

[1] Todd Gitlin. *The Sixties: Years of Hope, Days of Rage* (Bantam, 1987), 211.

[2] Ralph J. Gleason. *The Jefferson Airplane and the San Francisco Sound* (Ballantine, 1969), 68.

In many ways, the Grateful Dead were the musical part that stood for the psychedelic whole. Formed in 1965, the Dead participated in the so-called Acid Tests, which were sponsored by novelist Ken Kesey and the Merry Pranksters. By that time, their Saturday-night parties had outgrown Kesey's home in La Honda, and he initiated a series of off-site, open-ended public amusements that included LSD. Those events culminated in the Trips Festival, a three-day event designed to showcase avant-garde dance, theater, film, and music. Yet the Trips Festival is mostly remembered now for its combination of rock music, lights shows, psychedelic drugs, and freestyle dancing. As coorganizer Stewart Brand said later, it was the beginning of the Grateful Dead and the end of everything else. The next month, Bill Graham was hosting rock concerts at the Fillmore Auditorium. Soon after that, Chet Helms and the Family Dog were staging shows at the Avalon Ballroom. Over the next several years, both venues featured virtually every major rock act along with the local talent.

After moving to a large house at 710 Ashbury Street, the Grateful Dead became a pillar of the hippie community. As Joel Selvin has noted, there was no sharp distinction between the musicians and their neighbors, who were also the band's primary audience. They shopped at the same thrift stores, ate at the same restaurants, and took the same drugs. But the Grateful Dead also embodied the community's hopes and aspirations. Hip, irreverent, and authentic, they offered an attractive alternative to the mainstream culture's deadening routines and spiritual emptiness. Indeed, the band was living proof that hippies could make it on their own preferred terms.

The Dead's project was powered by three basic themes. The first was a commitment to ecstasy—not the drug, but the urge to transcend. Their emphasis on intense experience, which they inherited from their Beat heroes, reflected a key aspect of the counterculture as well as a specific conception of what it was to be an artist. A second theme was the Dead's commitment to mobility. As they toured the country, they elevated their geographical and psychic journeys to mythic importance. Their precursors—especially the Beats and Merry Pranksters—also associated mobility with freedom and discovery, but the Dead supercharged that impulse and created a larger social space for its expression. Finally, the Dead were dedicated to community. From the outset, their enterprise was tribal as well as utopian. They lived together in various configurations, shared their earnings more or less equally, and made decisions more or less democratically. As the touring operation expanded, so did the core group of employees, friends, and family. A large cohort of Deadheads ensured a steady stream of touring revenue and expanded the community far beyond the immediate tribe. Again, many precursors and peers emphasized community, but the Dead were uniquely successful at fostering it—so successful, in fact, that their community was thriving long after the band dissolved in the mid-1990s.

Although the San Francisco counterculture defined itself against mainstream society, the Dead spent little energy on critique. Indeed, their project didn't resist American culture so much as tap its inexhaustible utopian energies. Lead guitarist Jerry Garcia regarded the band as the American experiment in action. "We're basically Americans, and we like America," he said. "We like the things about being able to express outrageous amounts of freedom."[3] Always more than a series of shows, Grateful Dead tours became chances to experiment and innovate, not only musically but also personally. Even compared with their key influences, the Dead pushed their utopian ideals to another level through their music, organization, and community. The goal was to free themselves and their community from "normal" life. The Dead called that liberation getting high, and they sought to transcend ordinary experience through continuous experimentation and improvisation.

Their project's appeal wasn't lost on *Rolling Stone*, the San Francisco rock magazine that Gleason cofounded with Jann Wenner in 1967. By mentioning the Grateful Dead hundreds of times, beginning with its first issue, *Rolling Stone* boosted the band's profile far above its place in the music industry at that time. But if the magazine helped the Grateful Dead, that aid was mutual. Especially at the outset, the Dead possessed something that *Rolling Stone* needed: a reputation for authenticity, one of the counterculture's most valued assets. By championing the Grateful Dead, *Rolling Stone* claimed some of the band's countercultural cachet for itself.

The Dead seemed to appear at every major event associated with the counterculture—not only the Acid Tests, Trips Festival, and Human Be-In, but also the Monterey International Pop Festival (1967) and Woodstock Music and Art Fair (1969). They were also scheduled to play at the Altamont Speedway Free Festival, which was held in the windswept grasslands of eastern Alameda

3 Jerry Garcia, interview by Mary Eisenhart, November 12, 1987, *http://www.yoyow.com/marye/garcia4.html*.

County in December 1969. The culmination of the Rolling Stones' US tour, the event drew three hundred thousand spectators but was marred by poor planning and violence. Upon learning that Hells Angels had assaulted spectators and musicians alike, the Dead decided not to perform. When the Rolling Stones went on hours later, Hells Angels killed Meredith Hunter, a young Black man from Berkeley, in front of the stage. The mainstream media missed the story, but Rolling Stone's extensive coverage helped land the publication its first National Magazine Award.

Many notable photographers, including Baron Wolman and Annie Leibovitz, featured the Grateful Dead in Rolling Stone and elsewhere, but none photographed the Dead more successfully than Jim Marshall. That success was due in part to Marshall's familiarity with the Dead's lineage and habitat. Long before the national media converged on Haight-Ashbury, Marshall was photographing the Beats, Miles Davis, John Coltrane, Bob Dylan, and the Beatles, all of whom the Dead held in high regard. And unlike the reporters swarming through the Haight, Marshall lived in San Francisco and understood what he saw. When members of the Grateful Dead were arrested at 710 Ashbury for drug possession, he photographed their press conference. When the Dead closed off Haight Street to play a free concert, he captured the moment. When they ventured to Monterey, Woodstock, and Altamont, he was there. When Rolling Stone needed a cover photo of the Grateful Dead, the editors turned to Marshall.

The rise of the counterculture, both as a movement and as a media topic, furnished an extraordinary opportunity for Marshall. Although he was no hippie, he was instrumental in framing our understanding of the San Francisco counterculture. Indeed, no one saw that world as lucidly as he did.

A skilled and seasoned photographer, Marshall attributed much of his success to the special access he enjoyed to his subjects. That access, in turn, was rooted in the trust he acquired over the years. One anecdote captures the nature of that trust and its importance. In 1960, John Coltrane needed a ride from San Francisco to Ralph Gleason's house in Berkeley. Marshall gave Coltrane a lift, then asked if he could take some photographs. When the famously distant Miles Davis saw those portraits, one of which eventually hung in the White House during the Obama years, he permitted Marshall to photograph him onstage, backstage, and at the gym. The result was another set of masterpieces. By recognizing the Dead as worthy subjects, Marshall added them to the host of artists they revered.

Pigpen, Bill Kreutzmann, Phil Lesh, Rock Scully, Danny Rifkin, Bob Weir, Jerry Garcia, and Michael Stepanian at the Dead's news conference after their drug bust, 710 Ashbury. October 5, 1967.

Opposite, top: Pigpen, KQED-TV, *A Night at the Family Dog* special, Family Dog on the Great Highway. February 4, 1970.

Opposite, bottom: Jerry Garcia, 1970.

This page: Jerry Garcia, Lindley Meadow, Golden Gate Park. September 28, 1975.

Jim wasn't a hippie, but he was definitely a freak. Everybody knew this guy was not somebody that's trying to be like anybody else; musicians recognized that he was one of them. He was completely inner directed. Jim created himself, and that's who he was. He was definitely somebody who fit in with this world, but he was completely unique.

—Dave Getz

Jim Marshall shooting the Grateful Dead, across Geary Street from the Fillmore Auditorium, 1966.

The next milestone was the five bands and friends gathered at 710 [Ashbury] on the steps. It was herding cats, basically, to gather everybody in the five bands together so [Jim] could do a panoramic photo shoot in the Panhandle, which was two or three blocks down the street. It was the five San Francisco bands, all their friends and their spouses and their kids and their dogs.

—Rosie McGee

The five original San Francisco bands walking down Ashbury Street to the Panhandle for a group shot by Jim Marshall, 1967.

Above: Jerry Garcia, Jorma Kaukonen with Jack Casady on his back, John Cipollina.

Opposite: Dan Hicks, Jorma Kaukonen with Jack Casady on his back, Gary Duncan, Pigpen

My one main story about Jim is when he took the famous five-bands shot. That was shot in the Panhandle, which is a strip of green between Oak Street and Fell Street that runs a number of blocks leading up the entrance to Golden Gate Park at Stanyan. I had a top-floor flat that I shared with Marty Balin at 1994 Fell Street. Right across the Panhandle, down a couple of blocks, was Ashbury Street.

There's some film of that day; it shows this gaggle of unruly musicians all laughing and having a great time. Jim managed to corral all of us together and get that fabulous shot. He managed to get a lightness and a camaraderie in that photo that was obvious and evident at the time—but you don't always get it in the shot. He did.

Jim would hang with the best of 'em, and he had quite a vibrant personality, which some people could handle and some people couldn't. Jim was an artist in his own right. He wasn't out to make it big monetarily. He didn't organize his life that way. Like so many true artists, he wasn't out to maximize the Jim Marshall brand.

—Jack Casady

The five original San Francisco rock bands, the Panhandle, 1967.

Standing, from left:
Quicksilver Messenger Service (Greg Elmore, John Cipollina, Jim Murray); Grateful Dead (Bill Kreutzmann, Pigpen, Jerry Garcia); Big Brother & the Holding Company (Janis Joplin); Jefferson Airplane (Jack Casady, Marty Balin, Grace Slick, Paul Kantner, Jorma Kaukonen, Spencer Dryden); the Charlatans (Mike Ferguson, George Hunter, Dan Hicks, Mike Wilhelm, Richard Olsen).

Seated, from left:
Quicksilver Messenger Service (David Freiberg lying down, Dino Valenti, Gary Duncan); Grateful Dead (Bob Weir, Phil Lesh); Big Brother & the Holding Company (Sam Andrew, David Getz, Peter Albin, James Gurley).

Jim took the famous photo, and he took the photo of the five managers in a line, each with their hand in the pocket of the guy in front of him. That was probably Jim's idea. I mean, it's so him.

—Rosie McGee

Managers of the five original San Francisco bands, the Panhadle, 1967: Bill Thompson (Jefferson Airplane), Bill Graham (Jefferson Airplane), Julius Karpen (Big Brother & the Holding Company), Rock Scully (Grateful Dead), Ron Polte (Quicksilver Messenger Service), Danny Rifkin (Grateful Dead).

Pigpen, Jerry Garcia, and Spencer Dryden at
the Human Be-In, Polo Fields, Golden Gate Park.
January 14, 1967.

Grateful Dead at the Human Be-In, Polo Fields,
Golden Gate Park. January 14, 1967.

I always had the feeling that Jim was in a rush. I saw him more from the back than the front. He was focused on his targets; he had no interest in those of us who weren't in the band.

—Gail Hellund Bowler
Grateful Dead family member & sometime employee

Pigpen at the Human Be-In, Polo Fields, Golden Gate Park.
January 14, 1967.

Ken Babbs (left, in front of amplifiers), Grateful Dead, Woodstock, Bethel, New York. August 16, 1969.

Jerry Garcia, Woodstock, Bethel, New York. August 16, 1969.

Top: Marty Balin, Pigpen, and Jerry Garcia, Woodstock, Bethel, New York. August 16, 1969.

Bottom: Grateful Dead, Woodstock, Bethel, New York. August 16, 1969.

Top: Grateful Dead, Woodstock, Bethel, New York. August 16, 1969.

Bottom: Grateful Dead, Woodstock, Bethel, New York. August 16, 1969.

It seemed like Jim was just everywhere. My recollection of being in his place was that it looked like a super-busy professional photographer's place, with cameras all around.

Jim was very much just one of the guys. He was definitely a character.

I remember him at Woodstock; it wouldn't have been the same without him. You'd just expect him to be there. The way he was shooting at Woodstock was really something. You knew Jim was gonna get good shots.

—Michael Shrieve

Grateful Dead and Ken Babbs, Woodstock, Bethel, New York. August 16, 1969.

Jerry Garcia and Mountain Girl, Monterey Pop Festival. June 1967.

Jerry Garcia, Monterey Pop Festival. June 18, 1967.

Bob Weir, Jerry Garcia, and Bill Kreutzmann, Monterey Pop Festival. June 18, 1967.

Jim was there at so many significant events. He loved to insert himself in any kind of world where action was happening, whether it be fights or concerts or sporting events.

The amazing thing that I remember about Jim, particularly in today's world of unlimited snaps, is that he chose his images so well. The artist in him chose. If he had twelve or twenty-four or thirty-six in a roll, they had to be the "shots." He couldn't just fire off four thousand photos and go and pick something later—like picking a [frame] out of a movie or something.

Jim was an easy guy to spot. His personality was another matter altogether. You had your business to do, and Jim had his business to do; his was to insert himself. Jim was such a professional, you didn't care. With some photographers, you get the feeling they're experimenting on you, and they're annoying. With Jim, you never got that feeling. He was there to do his work, and he knew what his work was. Jim was there to capture the shot.

And he had only so much time. Jim waited, he watched the personalities, he studied the personalities, he hung on the personalities, and then he snapped that shot. He was trying to get those images that somehow captured the fact that the person was playing music or singing—which you didn't hear in a photo, of course, but somehow you got the feeling of that action—to translate that into the visual, to show the personality of the musician, the fighter, the athlete.

—Jack Casady

Bill Kreutzmann, final week of concerts at the Fillmore West. July 2, 1971.

Grateful Dead, final week of concerts at the Fillmore West.
July 2, 1971.

Grateful Dead proof sheet, last concert on Haight Street.
March 3, 1968.

187

Jerry Garcia, KQED-TV *A Night at the Family Dog* special,
Family Dog on the Great Highway. February 4, 1970.

Jerry Garcia and Bob Weir, Newport Pop Festival, Orange County Fairgrounds, Costa Mesa. August 4, 1968.

Jerry had a slew of those blue shirts. Those were called work shirts back in the day.

—Mountain Girl

Jerry Garcia's work shirt hanging in the dressing room of the Fillmore Auditorium, 1966.

Jerry Garcia, double exposure, 1968.

Eric Clapton and Jerry Garcia, Sausalito.
March 10, 1968.

Grateful Dead, lip-synching a song on KPIX-TV's *POW!* show,
San Francisco, spring 1967.

Grateful Dead, the Panhandle, 1967.

Bob Weir and Phil Lesh, Trips Festival, Longshoremen's Hall.
January 23, 1966.

Bob Weir, final week of concerts at the Fillmore West.
July 2, 1971.

At the shows, he just kind of hung back. He had five Leicas. You couldn't just have a couple of cameras [with] different lenses and take hundreds of pictures; you had to have the cameras loaded with film so it wouldn't interrupt the flow.

I was the girl with the camera. I had one camera with a fixed lens and a very limited budget for film and processing. I was just taking pictures—I've talked about my compulsion to document my life. I didn't know about professional photographers and licensing of photos and album covers and all that stuff. That was outside my knowledge.

Jim was methodical with what he was doing—where he placed himself and where he took the pictures.

Many times we shared the same vantage point on the side of the stage. One prime example of that was the Newport Pop Festival. There was a huge stage with a huge side-stage area. He and I shared the stage-right area.

As far as his relationship with me, let's face it: Jim liked the pretty, photographable girls, but he never flirted with me or came onto me or anything like that. I was never uncomfortable. We were always very friendly. And as far as I can remember, we never talked about photography. I didn't see Jim as a mentor or anything like that. We were just, like, two people with cameras. Jim was up to something different than what I was up to. But I didn't know it. I was the bass player's girlfriend with a camera. I mean, who knows what he thought, but he treated me with respect and kindness always. We laughed and maybe there was a little flirtiness, but nothing obnoxious at all. Which I have to point out, because in that scene and in that era, that wasn't always the case with the men.

—Rosie McGee

Rosie McGee, 1966.

Top: Bob Weir, Sky River Rock Festival, September 1968.

Bottom: Pigpen and Mickey Hart, Sky River Rock Festival, September 1968.

Top: Jerry Garcia, Sky River Rock Festival, September 1968.

Bottom: Bill Kreutzmann and Phil Lesh, Sky River Rock Festival, September 1968.

Pigpen, Bill Kreutzmann, Phil Lesh, and Jerry Garcia, Newport Pop Festival, Orange County Fairgrounds, Costa Mesa. August 4, 1968.

Bob Weir, Jerry Garcia, Bill Kreutzmann, and Jack Casady, Newport Pop Festival, Orange County Fairgrounds, Costa Mesa. August 4, 1968.

Bob Weir, Newport Pop Festival, Orange County Fairgrounds, Costa Mesa. August 4, 1968.

Bob Weir, Jerry Garcia, and Jack Casady, Newport Pop Festival,
Orange County Fairgrounds, Costa Mesa. August 4, 1968.

Grateful Dead, Newport Pop Festival, Orange County Fairgrounds, Costa Mesa. August 4, 1968.

Grateful Dead, Newport Pop Festival, Orange County Fairgrounds, Costa Mesa. August 4, 1968.

Bob Weir and Phil Lesh, Lindley Meadow, Golden Gate Park.
September 28, 1975.

Phil Lesh, Donna Jean Godchaux, and Bob Weir, Lindley Meadow, Golden Gate Park. September 28, 1975.

Grateful Dead, Lindley Meadow, Golden Gate Park.
September 28, 1975.

Phil Lesh, Lindley Meadow, Golden Gate Park.
September 28, 1975.

I'm a music nerd. As a teenager in college, I was a record collector. I always looked at the liner notes and saw who took the pictures. And consistently, the most interesting pictures I was seeing in *Rolling Stone* and other magazines, and on album covers, were Jim Marshall's. His was just a name that I was always aware of. Without Jim Marshall, there's no Annie Leibovitz. I think he's right up there with the greatest photographers of the twentieth century. I think the man was an artist.

—Bob Sarles

Bob Weir and Jerry Garcia, Lindley Meadow,
Golden Gate Park. September 28, 1975.

Ram Rod, Pigpen, and Sam Cutler, backstage at Winterland, 1971.

Grateful Dead, Santana, and Jefferson Airplane, KQED-TV
A Night at the Family Dog special, Family Dog on the Great
Highway. February 4, 1970.

Grateful Dead prior to "Dosing" process server

Opposite, top: Mickey Hart, Phil Lesh, and friends, 1969.

Opposite, bottom: Jim Marshall's description written on the back of this photo.

This page: Jerry Garcia, backstage at Winterland, 1971.

Jerry Garcia, KQED-TV *A Night at the Family Dog* special, Family Dog on the Great Highway. February 4, 1970.

Jerry Garcia and Wolf, Jerry Garcia Band (and later Grateful Dead) rehearsal and recording space, 20 Front Street, San Rafael, 1977.

FROM THE HAIGHT TO THE HEIGHTS

BY DAVID GANS

The Grateful Dead started out as a jug band in the bookstores and coffeehouses of Palo Alto, California. When the Beatles arrived and showed the world how much fun rock and roll can be, these folkies and their blues-singer pal Pigpen picked up electric instruments—and when Bob Dylan went electric, all bets were off! They called themselves the Warlocks at first, then adopted the name Grateful Dead in time to join the burgeoning San Francisco music scene, which became a sound and then expanded into a cultural revolution fueled by LSD, sexual freedom, and other advances of the '60s.

Owsley Stanley, the black sheep of an old Kentucky family who appointed himself the acid chemist to the stars (and delivered *magnificent* product), told me in 1991: "I joined up with a band that were Pranksters; they were part of the scene that was doing something right out on the edge of consciousness, the edge of social, the edge of magic, the edge of music—that was very dynamic, a band composed of five guys that were among the smartest people I'd ever run across. To find that many really smart people, people whose minds operated in the same function zone that mine did, could carry on the most tenuous and stratospheric of conversations with nobody gettin' lost—that blew my mind."[1]

The Pranksters—Ken Kesey's collection of cultural anarchists who crossed the country in a school bus with the stated mission of bringing *fun* to cities and towns from coast to coast—provided the Grateful Dead with a perfect setting in which to develop a musical style that merged familiar dance-party music with deep, interactive explorations: conversational improvisation. They threw collaborative, creative bashes in rented halls that they billed as "the Acid Test," and everyone was both entertainer and audience. The Dead were free to play their music without the need for the standard tropes of the time.

When the music business descended on the San Francisco scene, the Grateful Dead did it on their own terms: The Airplane and Big Brother had hit records and all that, while the Dead had to whip up a "single" at the last minute after Warner Bros. Records reviewed their first album and found it lacking. Amusingly, "The Golden Road (to Unlimited Devotion)"—a delightful brochure for the hippie movement—did not last long in the band's repertoire as they reached for a more ambitious project, inspired by Theodore Sturgeon's novel *More than Human*: merging their minds to form a single musical entity. In his autobiography, Phil Lesh said they wanted to be "the fingers on a hand."[2] Their performances mixed shorter songs from many idioms with extended improvisations in which every player had the power to dominate the rap and the good grace not to.

By inventing a form of music making that emphasized novelty and experimentation, the Dead attracted an audience that expected and welcomed a fresh experience every time, and that led them on a career path that emphasized live shows and did not rely on record sales for economic success. This proved to be a wise strategy for the long term, as thousands of fans attached themselves to this musical and social juggernaut and built a culture of lifelong fandom whose children, grandchildren, and great-grandchildren are still devoted to the music.

When Jim Marshall first crossed paths with the Grateful Dead, they were a neighborhood phenomenon that was just beginning to attract attention in the wider world. Marshall knew something was happening in his hometown, and he did what he always did: He committed world-class photojournalism that helped to make this magic visible.

The Grateful Dead photos in this book depict the band's rise from the Haight to the heights (of a sort). We see their appearances at major festivals in '68 and '69, from

1 David Gans. *Conversations with the Dead: The Grateful Dead Interview Book* (Carol Publishing, 1991).

2 Phil Lesh. *Searching for the Sound: My Life with the Grateful Dead* (Little, Brown, 2005).

Haight Street to Woodstock. Marshall photographed the band onstage, in dressing rooms, on the street, and in the house on Ashbury Street. He was at Winterland on New Year's Eve 1968, when two men rode through the audience on horseback.

(In the late stages of assembling this book, Amelia happened upon a strip of six negatives at the end of an unrelated roll shot some time in 1966: the five members of the band in the upstairs "parlor," posing in the late-afternoon sun with a variety of props including a firefighter's hat and a rusty BB gun! It has the feel of a spontaneous session, with Jim about forty-five degrees off axis and the band passing a joint and the hat from head to head between shots.)

Carolyn "Mountain Girl" Garcia recalled: "He'd just scurry around like a chipmunk and shove that camera up there with the lens about a foot long and get the picture. He was very good at it, as you can see. We used to be mad at him, and now we're pleased."

Jim photographed the Grateful Dead at intervals after those early days—group photos and the occasional portrait. Bob Weir told me in '78 that group photo sessions with Marshall usually devolved into mutual exchanges of (largely good-natured) abuse, "trying to make him cry."

• • • • •

Jim Marshall was an avatar of chutzpah—but it was chutzpah born of merit. Jim and his subjects were peers: He was every bit the genius, as much as the artists he photographed.

I've taken a lot of intimate photos of musicians and others, but they tended to happen in specific settings—usually in conjunction with a magazine interview (I did both text and photos in those days). Jim Marshall made it happen on his terms much of the time, and he usually did it in a way that allowed the effects of his bullishness to evaporate by the time the shutter opened.

I first heard of Jim Marshall when he took the cover photo for the 1971 debut album by the Doobie Brothers. Their bass player, Dave Shogren, was a good friend; I used to hang out during their rehearsals in a basement on Twelfth Street in San Jose. Dave made it clear that a Jim Marshall cover photo was a feather in the band's cap and a sign that the record company was serious about the band.

The cover is a black-and-white photo taken at the Chateau Liberté in the Santa Cruz Mountains. The four musicians look as though they've been surprised in the act of sharing a smoke. The ad campaign for the album used the tagline "The Doobie Brothers Mean Business." Not a happy-go-lucky vibe at all! It proved to be a successful launch, and the Doobie Brothers hit it very big a year or two later.

Once I became aware of Marshall, I started seeing his stuff everywhere in the press and on records, and I began to connect his name with some of the most amazing music photos I had ever seen: Miles Davis in the boxing ring; Johnny Cash giving a very enthusiastic finger to Jim's camera; the Beatles making their way to the stage at Candlestick Park in 1966; the five San Francisco bands posing en masse like a freakishly dressed football team, in vivid color. Jimi! Jerry! Janis! The Allman Brothers Band at the Fillmore East!

I met Jim in the fall of 1978, when I interviewed him in two sessions at his home for *BAM, the California Music Magazine*. He didn't point a gun at me, as he did to so many others of my acquaintance, but I did get to witness the full panoply of his personality: passionate, profane, pugnacious, and profoundly professional. In the interview (portions of which were heard in the Marshall documentary *Show Me the Picture*), he gave me a thorough and colorful accounting of his life and attitude, including a story about calling the feds on a record store that was selling a bootleg album with one of his photos on the cover.

Like so many other media and arts people who did business with him, I was alternately showered with gifts and abuse. More than once I got shut down on whatever I was trying to license, but then he'd send me home with a nice eight by ten, just because. When I signed on to write the text for Peter Simon's *Playing in the Band: An Oral and Visual Portrait of the Grateful Dead* (published in 1985), I learned that Peter had made a deal with Jim for a few photos. I approached him in hopes of acquiring a few more—Jim's Grateful Dead photos are absolutely essential to this story—but I got an earful of obscenities and eventually gave up my effort. We stuck with the ones we had already contracted for.

I don't think I even tried to buy photos from him in 1991 for *Conversations with the Dead*, 'cause Herbie Greene was so much easier.

Working on *The Grateful Dead by Jim Marshall* with Amelia has been a pleasure and an education. I took a lot of photos in my music journalism days (I gave up printing my own images after I saw how much better they looked when Peter Simon printed 'em!), so I have a practical appreciation of what Jim did and how great he was at his job. People who look through his proof sheets always remark on the paucity of duds; we who cheerily snap hundreds of phone-cam images every day stand in awe of a man who knew intimately the limitations of a thirty-six-shot roll of Tri-X and exploited every square inch of the available terrain to deliver immortal photographs that no one else could have made.

I knew Jim Marshall just well enough to know that everything in this book is true.

As Carolyn "Mountain Girl" Garcia told me in February 2024: "He rarely asked, 'Is it OK if I take a picture?' He would just do it. But look what he got: beautiful pictures. Thank you, Jim."

Jim took incredible pictures under very difficult circumstances; let's face it. You know, he had to deal with not being tall, for one thing. He managed to get all these pictures without causing a lot of trouble. Other photographers were sort of discouraged after a while, and he kind of had free rein with taking pictures.

—Mountain Girl

Jerry Garcia, 710 Ashbury, 1967.

Mountain Girl and Jerry Garcia, 710 Ashbury, 1967.

Michael Bloomfield, Mountain Girl, and Jerry Garcia,
backstage at the Fillmore Auditorium. October 9, 1966.

Jerry Garcia, Michael Bloomfield, and Jorma Kaukonen,
Fillmore Auditorium. October 9, 1966.

Nineteen sixty-six is when I first met Jim. He was right in there with us, with Herbie Greene and me and all the musicians, the artists. We were all very good friends, a community.

Jim wasn't part of the community of very close friends that got high together and all of that. But he was always there, and it was mostly at gigs. In hindsight, I totally understand what he was up to, and he was very good at it. He was a professional already. Later on, obviously, he went on to do hundreds of album covers and *Rolling Stone* and this and that and the other. He was a dedicated, full-time

professional photographer, which was a whole different animal from what I was doing.

Nineteen sixty-six was the first time that I'm aware of him taking a photo of me. That was the photo of me dancing under a strobe light. At the Fillmore, off the edge of stage right, there was this—really annoying, in hindsight—this big strobe light. I love that photo. I didn't see it till later.

—Rosie McGee

Rosie McGee and Phil Lesh in the dressing room of the Fillmore Auditorium, 1966.

Phil Lesh in the dressing room of the
Fillmore Auditorium, 1966.

Rosie McGee in the dressing room of the
Fillmore Auditorium, 1966.

232

There was a little rivalry going on with Michael Bloomfield. I know he had Jerry worried that maybe he wasn't gonna be the best guitar player on the block if Bloomfield hung out too much. Bloomfield was awful good. They had very different approaches; they played different stuff, and that was lucky.

—Mountain Girl

Michael Bloomfield and Jerry Garcia, San Francisco, 1968.

Bill Kreutzmann, 710 Ashbury, 1967.

Grateful Dead, 1967.

Bill Kreutzmann, 1967.

Bob Weir, backstage at Winterland, Trip or Freak
Psychedelic Art Exchange. October 31, 1967.

I always really respected Jim's work: There's some quality that he was able to capture with the camera that so many of those other photographers just couldn't possibly get. Like I say, Jim was like a war correspondent, really. I mean, he just got these great views that reflected people's soul in a way that I think is very difficult, impossible to teach, and hard to replicate.

—Jorma Kaukonen

Grateful Dead at 710 Ashbury, 1966.

This photo was taken in the upstairs living room. A Victorian house has to have two living rooms, you know! Bobby's got a headdress made of turkey feathers. Looks like that's what he's gonna wear to the show that night.

And Bill's got my old, completely rusted BB gun. This was a Prankster item made by Ken Kesey. No danger to anyone. Once in a while it shot a BB, but it hasn't for a long time.

The cognitive dissonance of Grateful Dead guys holding guns has always been a weird thing in this culture. So to explain that it was just a fucking BB gun will relax a lot of people. Not only was it a BB gun, but it was very old and rickety and shot BBs at a very slow rate. So they'd come out the front end of the gun and go about fifteen feet and then fall. Not good for plinking.

This is a lovely picture of the band as it was in those days, with Bill looking so young, Phil with his usual shaggy-dog haircut, Bobby with no shoes, Pigpen just waiting for things to liven up, and Jerry wearing his hat.

The thing about Jim was, man, once he got going, he could zip from one side to the other and get another picture before you could even notice that he'd moved.

Look at that beautiful chair. That house. It just was so rococo inside with all that beautiful woodwork. It was super. What a great place to live. You can tell this was taken in the afternoon 'cause the sun would just pour in in the afternoon. The house faced west. Everybody would hang out in the afternoons when they weren't rehearsing in the upstairs parlor.

—Mountain Girl

Grateful Dead at 710 Ashbury, 1966.

243

Bob Weir, Artists Liberation Front Free Fair in the Panhandle. October 16, 1966.

Bob Weir, Northern California Folk-Rock Festival, Santa Clara County Fairgrounds, San Jose. May 18, 1968.

Grateful Dead, Winterland, 1971.

Rock Scully and Bob Weir, Monterey Pop Festival, June 1967.

Mountain Girl and Jerry Garcia,
Monterey Pop Festival, June 1967.

Rock Scully and Danny Rifkin,
710 Ashbury, 1967.

This photo shows Pigpen with his full regalia on. He's got on all his buttons. You'll notice that the button on the pocket on the right-hand side says "Acid Test"; he wore that proudly. And then on his shoulder it says "Smiling Service." He collected that kind of stuff, and pretty soon that jacket filled up with different good buttons and sayings. He rarely liked to have his picture taken, so this is kind of a rare picture.

—Mountain Girl

Pigpen, 710 Ashbury, 1967.

Pigpen used to babysit me. He was my favorite babysitter because he would let me get away with everything. He'd gimme as many french fries or Coca-Colas as I wanted.

—Sunshine Kesey

Pigpen and Sunshine Kesey, 710 Ashbury Street, 1967.

Jerry Garcia and Pigpen, Artists Liberation Front Free Fair in the Panhandle. October 16, 1966.

Jerry Garcia, New Year's Eve, Winterland.
December 31, 1968.

Jerry Garcia and Bob Weir, Winterland, 1971.

Jerry Garcia, double exposure, Fillmore West.
January 4, 1969.

Jerry Garcia, triple exposure, Fillmore West.
January 4, 1969.

Grateful Dead, Newport Pop Festival, Orange County Fairgrounds, Costa Mesa. August 4, 1968.

Bob Weir, Newport Pop Festival, Orange County Fairgrounds, Costa Mesa. August 4, 1968.

Bob Weir, Newport Pop Festival, Orange County Fairgrounds, Costa Mesa. August 4, 1968.

Rosie McGee dancing onstage with the Grateful Dead, Newport Pop Festival, Orange County Fairgrounds, Costa Mesa. August 4, 1968.

Rosie McGee dancing onstage with the Grateful Dead, final week of concerts at the Fillmore West. July 2, 1971.

Bob Weir, final week of concerts at the Fillmore West.
July 2, 1971.

Jerry Garcia, Northern California Folk-Rock Festival, Santa Clara County Fairgrounds, San Jose. May 18, 1968.

Janis Joplin, Artists Liberation Front Free Fair in the Panhandle. October 16, 1966.

Janis Joplin and Pigpen were very fond of each other. This photo was taken in San Jose at that folk-rock festival. Janis just loved the whole Grateful Dead scene. Whenever Big Brother and the Grateful Dead were gigging together, Janis was pretty much right in the middle of us. What a wonderful soul she had. She was just incredible.

Janis and Pigpen were very good friends, but they didn't sing each other's songs. They tried to have separate material, even though they were both blues singers.

Miss Janis: She just took the whole thing by storm. Pigpen was totally smitten by Janis, but really she had so many people to choose from. I think they didn't ever have a serious get-together other than singing together. But he really loved her.

—Mountain Girl

Janis Joplin and Pigpen, Northern California Folk-Rock Festival, Santa Clara County Fairgrounds, San Jose. May 18, 1968.

Pigpen, Fillmore West, 1968.

Jerry Garcia, double exposure with light show, Winterland, 1971.

270

When Jim Marshall arrived in studio, my first impression was that he was a confrontational asshole. I figured out in later years that Marshall's confrontation, his "taking a subject out of their own comfort zone," was his method of capturing great images.

He hated taking "poses" and only did so at the request of the client, such as for the "iconic" photo of me on the back cover of David Crosby's album *If I Could Only Remember My Name*. It was taken in the hallway directly under a floodlight. Jim first took a photo of Ellen Burke and me at the same spot, but Ellen showed discomfort, so he unapologetically dismissed her and continued to shoot just me. His method included taking a lot of exposures, while the rest of us worried about processing costs.

Jim would never use flash, only available light. That was my favorite mode of photography, and knowing this enhanced my respect for him.

All the *IICORMN* recording sessions, however, normally took place with the lights dimmed down, with just enough light not to trip over things, like in a small club. It was the required mode. I would have never turned up the lights for any reason, as the performance and the music were why we were here, and they would have suffered.

The first thing Jim did was blow the mood by turning up all the Variacs in the room to full brightness. Kodak Tri-X film, pushed in developing to eight hundred, could get a usable image—but sixteen hundred had too much grain, so I realized he had to do what I didn't have the courage (or permission) to do.

—Stephen Barncard
recording engineer and co-producer of *American Beauty*

Proof sheet, PERRO (the Planet Earth Rock and Roll Orchestra) recording sessions, Wally Heider Studios, 1971.

Top: Jerry Garcia, PERRO (the Planet Earth Rock and Roll Orchestra) recording sessions, Wally Heider Studios, 1971.

Bottom: Neil Young, PERRO (the Planet Earth Rock and Roll Orchestra) recording sessions, Wally Heider Studios, 1971.

I was going to be in Jefferson Airplane before Santana. Not many people know that! I would go over to Fulton Street all the time and jam with them.

During the Planet Earth Rock and Roll Orchestra recording sessions at Wally Heider Studios, Santana was recording *Abraxas*; Creedence Clearwater was recording the big hit record [most likely *Cosmo's Factory*]; and then Jerry, Neil, David, and Phil came in, and David invited me to play.

I aspired to be a jazz drummer. And when I hear myself playing on that record [*If I Could Only Remember My Name*], it sounds very hippie to me. People over the years have said that's one of their favorite records. I never even mentioned it, 'cause I don't care for the way I sound on it. I never quite figured out how to play that way, you know? I thought I wasn't serving the music correctly.

—Michael Shrieve

This page: David Crosby, Michael Shrieve on drums, PERRO (the Planet Earth Rock and Roll Orchestra) recording sessions, Wally Heider Studios, 1971.

Phil Lesh, PERRO (the Planet Earth Rock and Roll Orchestra) recording sessions, Wally Heider Studios, 1971.

Michael Shrieve and Phil Lesh, PERRO (the Planet Earth Rock and Roll Orchestra) recording sessions, Wally Heider Studios, 1971.

Bob Weir and Jerry Garcia, final week of concerts at the Fillmore West. July 2, 1971.

Bob Weir, final week of concerts at the Fillmore West. July 2, 1971.

We got a sense that we were recording a period in history that people would be wanting to visit later. I have a lot of students coming in who weren't even born during that period and are very interested in that period. They're using all the photos and the text for their term papers.

It's amazing when you go to a Dead concert how many young people are there in their tie-dye and dancing to the music, and they weren't even alive during that era. The Grateful Dead seems to be the one that's continued on, and that's why I've given up on predictions. They were one of the bands that played on Haight Street, and they played at the Straight Theater and the Fillmore, but that they would become nationally popular and create this culture, I couldn't have predicted.

—Dr. David Smith
founder of the Haight Ashbury Free Clinic

Grateful Dead, Speedway Meadow, Golden Gate Park.
July 4, 1967.

AFTERWORD

BY JOHN MAYER

"I've got scotch older than you!"

That's what Jim Marshall said to me once at dinner, when I had a night off on tour in San Francisco. I didn't understand the mechanics of time then; no twentysomething does. Forget about the whiskey; Jim had photographs that were older than me, and later that night I would end up at his house, poring through long, flat metal drawers of unframed, unsigned prints. As I showed him each one that I loved, he would tell me all about it. "That's an old Kodak print that's not around anymore," he told me in reference to the beautiful shot he took of Otis Redding at the Monterey Pop Festival. The chemical emulsion that produced the most gorgeous, vibrant colors I'd ever seen in a photograph had since been outlawed by the EPA due to environmental and health concerns. That made the work even more rock and roll than it already was; these were illicit works, relics from the freewheeling days that had come and gone. That made me want them even more.

Jim continued to lament the passing of time; he told me that photographing musicians had become something that hemmed him in. The photograph of Janis Joplin I was holding reminded him of how he'd had unguarded and endless access to her. He knew that nowadays, it would be impossible to get a shot of a singer lying on a couch with a bottle of Southern Comfort in hand. It was publicists that now stood in the way of magic happening. "These days you get thirty minutes with an artist, and they pull them away," Jim said. He knew there was no way to make these photos again. And so did I.

By the end of the evening, I'd amassed a stack of photos that I showed to him one at a time as he wrote numbers down in pencil on a small sheet of paper. This was how Jim did business. There was no gallery director, no middleman. He signed each one in front of me, next to the edition number, which had already been written.

There was Cream, standing stoically together, hinting at the underlying tension inherent in all trios. There was John Coltrane, printed with a platinum chemical process, sitting deep in thought with his hand against his face. The most moving to me was another shot of Coltrane, standing at dawn in his backyard at his home in New York State. There was also Jimi Hendrix at the Monterey Pop Festival, pointing toward the camera with his eyes wide open, recognizing Jim and playing straight to him. There was Thelonious Monk, and Miles Davis, and Bill Evans. I loved that Jim had taken the greatest photos of jazz musicians, even though these were somewhat overshadowed by his work with more famous pop and rock musicians of the time.

Jim came to my concert the next night. Knowing how the changing of the guard had affected his enthusiasm for taking photos, I gave him the access he had said was long gone. I'm so glad I did. Hanging in my house, next to these classic photos I mentioned, is a photograph he took of me onstage playing the guitar, a baby-faced kid who was younger than the scotch in his liquor cabinet. The film was newer, and the development process a little flatter. But the rest is classic Jim Marshall.

To have known Jim Marshall is to have communed with the type of artist that exists in short supply these days: a man who brought his battered Leica everywhere he went, even to dinner, where it sat on the table like his faithful companion. He'd dedicated his life to capturing the essence of musicians, and since his passing, I now find myself referring to the essence of who he was: a singular artist who was no different from the rock stars he immortalized. I'll never forget his unlikely swagger, his distaste for the bullshit, and his love for honesty and straight shooting. In every photograph he made featuring an enduring rock and roll icon, there was another you might have missed—the one holding the camera.

John Mayer photographed by Jim Marshall in Los Angeles in 2004.

About the Contributors

AMELIA DAVIS, owner of Jim Marshall Photography LLC, was legendary photographer Jim Marshall's longtime personal assistant. Upon his death in 2010, Marshall left his entire estate to Davis to carry on his legacy. Since his passing, Davis has edited six Jim Marshall monographs and curated yearly photographic exhibitions of Marshall's work; in 2019, she was the executive producer of the award-winning feature-length documentary on the life of Jim Marshall, *Show Me the Picture: The Story of Jim Marshall*. Davis, a San Francisco–based award-winning photographer, has three books of her own: *The First Look* (about breast cancer survivors), *My Story: A Photographic Essay on Living with Multiple Sclerosis*, and *Faces of Osteoporosis*. Davis continues to preach the "gospel" of Jim Marshall.

DAVID GANS is a California-born musician, author, and radio host. Over the course of his ten years (1976–1986) as a mainstream music journalist, Gans got to know Jim Marshall fairly well. He also developed friendships with members of the Grateful Dead and became a trusted member of the band's extended family. Gans has since published five books about the Grateful Dead and produced boxed sets, compilations, and tribute albums for the band. His first book (with Peter Simon), *Playing in the Band: An Oral and Visual Portrait of the Grateful Dead*, ultimately led to a gig hosting San Francisco radio station KFOG's *Deadhead Hour*, which by the summer of 1987 was syndicated across the country (and continues to this day as *The Grateful Dead Hour*). He consulted on the creation of Sirius Satellite Radio's Grateful Dead Channel, and since January 2008 has been a cohost of *Tales from the Golden Road*, a weekly talk show on the channel. His most recent book, *Improvised Lives: Grateful Dead 1972–1985*, features his own photos of the band. Gans lives in Oakland, California, with his wife, Rita Hurault, and two delightful cats, Percy and Ringo.

A Bay Area–based music journalist for nearly five decades, **BLAIR JACKSON** has also written numerous books, including *Grateful Dead: The Music Never Stopped*, *Grateful Dead Gear*, *This Is All A Dream We Dreamed: An Oral History of the Grateful Dead* (with David Gans), and *California Dreams: The Art of Stanley Mouse*. Through the years he worked as a writer and editor for magazines such as *BAM*, the recording industry journal *Mix*, *Acoustic Guitar*, *Classical Guitar*, and *Ukulele*.

There's nobody quite like **JOHN MAYER**. He has emerged as a Grammy Award–winning artist, celebrated songwriter, and iconic guitar player all at once. The Bridgeport, Connecticut, native introduced himself on the quintuple-platinum *Room for Squares* in 2001 and has earned three #1 debuts on the *Billboard* Top 200 with the triple-platinum *Heavier Things* (2003), double-platinum *Battle Studies* (2009), and gold *Born and Raised* (2012). In addition to selling more than twenty million albums worldwide and gathering billions of streams to date, he has garnered seven Grammy Awards, including *Song of the Year* for "Daughters," and has earned a record seven US #1 albums on Billboard's Top Rock Albums chart and twenty-five entries on the Hot Rock Songs chart, the most for any solo artist. In 2015, Dead & Company was founded, with Mayer on vocals and lead guitar, and quickly became one of the most successful bands. The band had ten US tours, including a highly successful thirty-show residency at Sphere in Las Vegas that drew nearly half a million attendees. Dead & Company has played to almost five million fans across three hundred shows and has become a record-breaking stadium act. In addition, more than $15 million has been raised to support nonprofits and environmental and social causes. In 2021, *Sob Rock*, Mayer's eighth studio album, was released to critical acclaim featuring the hits "Last Train Home" and "Wild Blue." In November 2023, *Life with John Mayer* launched, an exclusive, 24/7, year-round SiriusXM channel curated and presented by Mayer.

PETER RICHARDSON has written critically acclaimed books about Hunter S. Thompson, the Grateful Dead, Ramparts magazine, and radical author and editor Carey McWilliams. He is currently writing a book about the first decade of Rolling Stone magazine. Richardson's essays and book reviews have appeared in The Nation, The New Republic, the Los Angeles Times, the San Francisco Chronicle, and many other outlets. From 2006 to 2023, Richardson taught courses on California culture at San Francisco State University. Frequently quoted in major US newspapers, he also has been featured in documentary films, podcasts, and public radio programs in North America and abroad. He holds a PhD in English from the University of California, Berkeley. Born and raised in the East Bay, he now lives in Sonoma County.

BILL SHAPIRO is the former editor-in-chief of Life magazine; later, he served as the founding editor-in-chief of Life's website, life.com, which won the 2011 National Magazine Award for digital photography. Shapiro is the author of several books, among them Gus & Me, the bestselling children's book he cowrote with legendary Rolling Stones guitarist Keith Richards. He is also a contributing editor to the Leica Conversations series. Shapiro has written about photography for the New York Times Magazine, Esquire, Vanity Fair, Vogue, the Atlantic, Oprah, and New Mexico Magazine, among others. On Instagram, he's @billshapiro.

DAN SULLIVAN is a passionate music fan and amateur music historian, and has been a Deadhead for the past forty-five years. He first met Jim Marshall, Amelia Davis, and Bonita Passarelli in 2002 at an introductory dinner arranged by his new sweetheart (and Marshall's ex), Michelle Margetts. Marshall's very first words to Sullivan: "If you break her heart, I'll fucking kill you." To which Sullivan responded, "Oh yeah? What'll you do if she breaks *my* fucking heart?" Marshall cracked up and laughed hard. Until his death in 2010, he always made Sullivan feel welcome. Sullivan retired in 2020 after a long career as an NGO representative at the United Nations, a PhD student in German history, and an administrator at the University of California, Berkeley's Haas School of Business. He never broke Margetts's heart: The two were married in 2018 and live today with their cats, Janis and Grace, in Alameda, California.

286

Acknowledgments

I am so grateful to David Gans for the time he spent with me looking through hundreds of proof sheets and slides to narrow down the images for this book. Jim's images are not only historical but also tell a story of the Grateful Dead and the city we all love, San Francisco. David was also generous with his time in gathering the amazing stories featured in this book. It was such a natural journey we took together.

My good friend and Deadhead Dan Sullivan: What can I say? Thank you; you went down the many rabbit holes and devoted countless hours of research to ensure this book was as accurate as it could be with names, places, and dates. We could not have done it without you, and I am forever grateful.

Bill Shapiro, you gave a true picture of Jim Marshall as one of the most important photojournalists of the twentieth century. You reminded us all of Jim's genius with wit and humor.

Peter Richardson, you placed Jim Marshall as one of the greats in the history of music of the 1960s and '70s in San Francisco alongside the musicians and promoters. I thank you for this.

Blair Jackson, I appreciate your honest story about what it was like dealing with Jim Marshall on a business and personal level. We all have our own Jim Marshall story.

John Mayer, thank you for the candid Afterword and continued friendship to Jim; you are a rock star.

Thank you to everyone who shared their unique stories about Jim Marshall and the Grateful Dead with us: Mountain Girl, Sunshine Kesey, Jorma Kaukonen, Jack Casady, Dave Getz, Herbie Greene, Rosie McGee, Justin Kreutzmann, Dennis McNally, Donna Jean Godchaux-MacKay, Bob Sarles, Michael Shrieve, Pattie Spaziani O'Neal, Dr. David Smith, Gail Hellund Bowler, and Stephen Barncard.

Bonita Passarelli, my celestial Gemini partner, helped with every aspect of this book and is the sunshine that shines on me to keep me warm and safe every day. Thank you for your unconditional love.

And finally, thank you, Chronicle Books, for being such a wonderfully collaborative partner in publishing quality books of Jim Marshall's photographic legacy.

Proof sheet, Grateful Dead, 1967.

He was kind of like a war correspondent, you know, and his war was us.

—Jorma Kaukonen

Grateful Dead, the Panhandle, 1967.